# the daily zoo

## year 2

*still* keeping the doctor at bay
with a drawing a day

# Chris Ayers

designstudio|PRESS

For Thasja,
my old friend, new bride, and true love.

ACKNOWLEDGMENTS

Another volume of *The Daily Zoo* would not have been possible without the continued support of a great many people, first and foremost my wife Thasja, my parents Nan & Jim, and my sister and soon-to-be brother-in-law Colleen & Aaron. Also, thanks again to the Design Studio family (Scott, Tinti, Daniela, Melissa, and Sergio) for another foray into the adventurous world of publishing. I also have much appreciation for the many *Volume One* readers who have responded with such enthusiasm and encouragement—I hope the sequel lives up to the expectations. And I would be remiss if I did not once again express my thanks to Dr. Gary Schiller and the entire UCLA team for their high level of continued compassion and care. To all of you, *thank you* for helping me continue the journey of *The Daily Zoo*.

**Contact info:**
To contact the artist please visit www.chrisayersdesign.com

pg. 1: Day 421 - Slug
pg. 2: Day 639 - Turning of the Tide, No. 2
pg. 5: Day 674 - Amphibious Anxiety
pg. 122: Day 673 - Beached Octopus
Back cover: Day 690 - Hanging Frog

Copy Editors: The Editorial Ayers Women & Tinti Dey
Book Design & Production Layout: Chris Ayers
Photography credits: Thasja Hoffmann (p.7)

Published by Design Studio Press
8577 Higuera Street
Culver City, CA 90232
http://www.designstudiopress.com
E-mail: info@designstudiopress.com
10 9 8 7 6 5 4 3 2

Printed in China
First Edition, November 2009

Hardcover ISBN 13: 978-193349247-6

Paperback ISBN 13: 978-193349244-5

Library of Congress Control Number: 2009939824

# contents

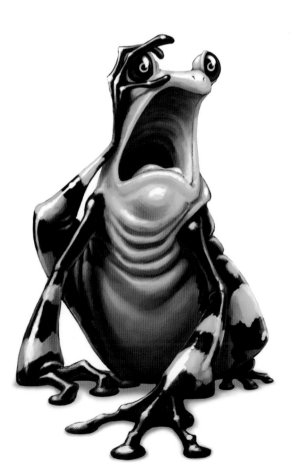

| | |
|---|---|
| Introduction | 6 |
| April | 8 |
| May | 16 |
| June | 26 |
| July | 32 |
| August | 40 |
| September | 48 |
| October | 58 |
| November | 74 |
| December | 86 |
| January | 96 |
| February | 104 |
| March | 110 |
| Year Two in Review | 122 |

# introduction

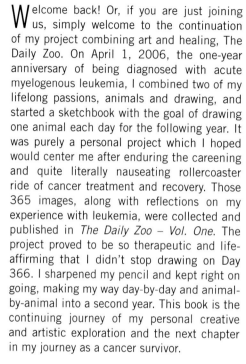

Welcome back! Or, if you are just joining us, simply welcome to the continuation of my project combining art and healing, The Daily Zoo. On April 1, 2006, the one-year anniversary of being diagnosed with acute myelogenous leukemia, I combined two of my lifelong passions, animals and drawing, and started a sketchbook with the goal of drawing one animal each day for the following year. It was purely a personal project which I hoped would center me after enduring the careening and quite literally nauseating rollercoaster ride of cancer treatment and recovery. Those 365 images, along with reflections on my experience with leukemia, were collected and published in *The Daily Zoo – Vol. One*. The project proved to be so therapeutic and life-affirming that I didn't stop drawing on Day 366. I sharpened my pencil and kept right on going, making my way day-by-day and animal-by-animal into a second year. This book is the continuing journey of my personal creative and artistic exploration and the next chapter in my journey as a cancer survivor.

First up, a brief update on the status of my health. Fortunately, the intensity of the cancer journey has, for the most part, passed. I recently celebrated four years of remission and I'm feeling pretty good overall. There have been a few little health issues—though after cancer even *little* health issues don't always seem that little—but luckily I haven't had to deal with anything major. Despite my best intentions, however, my medical vocabulary does continue to expand with terms and phrases like moderate

Aristocratopus - Day 698

atypia, acyclovir, excision biopsy, liver function numbers, etc…but I'm just happy to still be here. Even now that I am in remission, cancer is still a companion on my life's path. It's just that the nature of my relationship with it has changed, and will continue to change, as the days pass (and hopefully turn into many, many years!). I'm still learning what it means for me to be a cancer survivor and how that affects both my everyday decisions and my long-term outlook on life.

As I set out on Year Two, I was curious to see if the motivation and enthusiasm would be harder to come by. After all, I had already achieved my original goal of an animal a day for a year. Would there be as much incentive for doing a second year? What I discovered is that the process has transformed from the big goal of completing a year's worth of drawings to just the enjoyment of the daily adventure with pencil and paper (or brush and canvas; stylus and pixels). I don't tend to think in yearly terms as much as I think in the present moment—what will I discover *today?*

Year Two was not without its challenges and obstacles. There were days when I was stuck for inspiration and would seek it out by flipping through a reference book or turning to one of my brainstorming tricks. When I didn't have a lot of energy or was extremely busy, I would do a quick sketch rather than something more elaborate. There were some late nights where I thought to myself: Wouldn't it be nice *not* to do it today? Just take *one* day off? But the thought of stopping is a little scary, not so much because the streak would be broken, but because I would miss out on that dose of

creative discovery and play. With the inevitable busyness of life, I think it might be all too easy to let one day off turn into two and then three...and before I know it, a week may have gone by without making time for my personal art.

The second year was also fueled by the excitement of turning the first year into a book. I received the green light to publish in October 2007, a little over halfway through Year Two. While it was challenging to make time for both designing that first book and continuing the daily sketch (not to mention freelance work and all of life's other activities and demands), it was ultimately very rewarding. The fact that the first book has resonated with an audience as varied as professional artists, lunchtime doodlers, doctors, patients, cancer survivors, zookeepers, and children of all ages, reaffirmed that this project was worth continuing, not just for myself but for others as well. One reader shared that *The Daily Zoo* was referred to as the "silly animal book" in his house and that it had helped him explain to his young children their own grandfather's battle with cancer.

Truth be told, The Daily Zoo has me hooked. I've become dependent on that rush of creative adrenaline coursing through my imagination. Our bodies need such things as proteins and nutrients to function properly but in order to really be *alive* I feel the need to unlock my creativity with these daily drawing sessions, unveiling vibrant characters that I did not even know my imagination contained. I strongly suspect that we all need to feed our own creativity and in doing so fan the creative flames of others' as well. We don't live in a vacuum. The more people are pursuing their passions with determination and enthusiasm, the more it can inspire others to do the same. Active imaginations, big "impossible" dreams, and hard work can make our world a colorful, exciting, and rich place to spend our days.

In many ways my experience with leukemia has been a gift and, despite its inherent nastiness, cancer has been rocket fuel for my soul. It has provided me with more appreciation,

motivation, and drive than I had before. Of course it nearly killed me first, and it may cause complications down the road, but for today—for this moment—I'm only going to concern myself with feeling the breeze on my face; taking a deep, energizing breath of gratitude; and trying to decide what today's animal should be.

I invite you to turn the page and join me in another year of traveling through my imagination...another year of "silly animals"...another year of The Daily Zoo!

July 27, 2009
(Day 1,215 of The Daily Zoo)

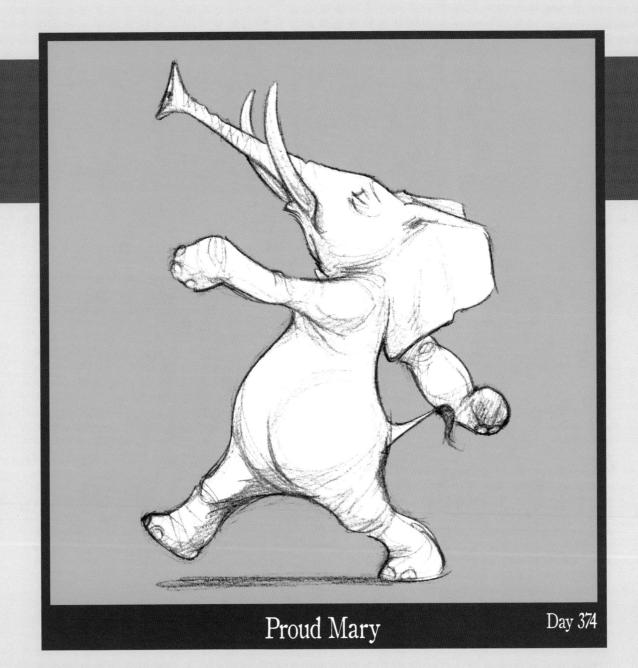

Proud Mary

Day 374

Cancer, or any serious illness, is a challenging thing to face. It can beat you down. How do you find strength to walk tall and confident when ill? How do you retain your dignity as a patient when you're feeling weak and vulnerable, attached to machines feeding you chemicals that most likely will leave you sterile, wearing a floral print hospital gown? It's tough.

Fortunately, in my case, I was able to gather strength from the love of family and friends and the professionalism of the UCLA medical staff. But at some point it does come down to *you*. I learned that you have a choice of how you are going to handle the challenges and the setbacks, the ups and (mostly) downs of the cancer rollercoaster. You can give in to defeat...or you can fight it with all the dignity, humor, and positivity you can muster.

I made my choice very early on, so early in fact that I hadn't even realized I had made it. About eight months after my diagnosis I was well into my recovery and talking with a friend at a holiday party. She told me she was impressed that I had handled the whole ordeal with such strength. Turning slightly red, I replied, "I didn't have a choice. I had cancer. I did what I had to do."

Then she opened my eyes. "No, you *did* have a choice. You chose how you wanted to handle it." I hadn't thought of it in those terms before, mainly because I didn't consciously recall making any big life-or-death choices. It all happened so fast: diagnosis, hospitalization, the start of chemo.... In hindsight, I think I made my choice in the split second after being told I had cancer. As the shock turned to numbness, I asked the doctor what the next 24 hours would entail for me. That was about as far ahead as I could think at the time, but already I had made my decision. Ready or not, I was going to fight.

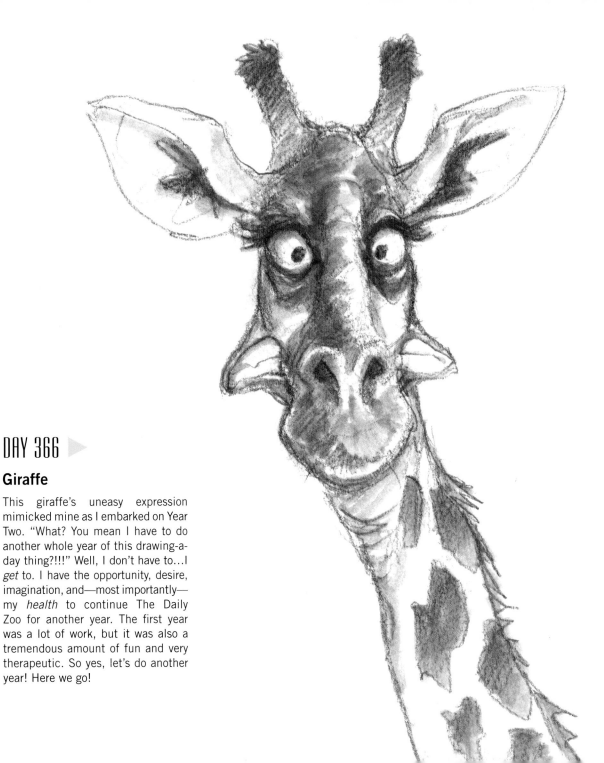

# DAY 366 ▶

## Giraffe

This giraffe's uneasy expression mimicked mine as I embarked on Year Two. "What? You mean I have to do another whole year of this drawing-a-day thing?!!!" Well, I don't have to...I *get* to. I have the opportunity, desire, imagination, and—most importantly— my *health* to continue The Daily Zoo for another year. The first year was a lot of work, but it was also a tremendous amount of fun and very therapeutic. So yes, let's do another year! Here we go!

## Gorangutan

In Year Two I continued to travel with my sketchbook, never knowing when I'd have the time to sketch or when inspiration might strike. This particular image was created at a coffee shop after spending the day at the Los Angeles Zoo. I was waiting to meet my wife and thought it would be fun to combine certain distinguishing physical traits of both a silverback gorilla and a mature male orangutan into one character.

# DAY 368 ◀

## Gila Monster

Some of the animals in The Daily Zoo are one-off characters—that is, as I'm drawing I don't have a lot of context of the world in which that individual lives. Sometimes, however, I envision the animal as a cast member of a story I'd eventually like to tell. Here I was imagining one resident of a small, dusty outpost in the Old West. Someday I'd like to explore what the other townsfolk might be like. The eager deputy? The crusty barkeep? The reluctant saloon dancer? The villainous train robber?

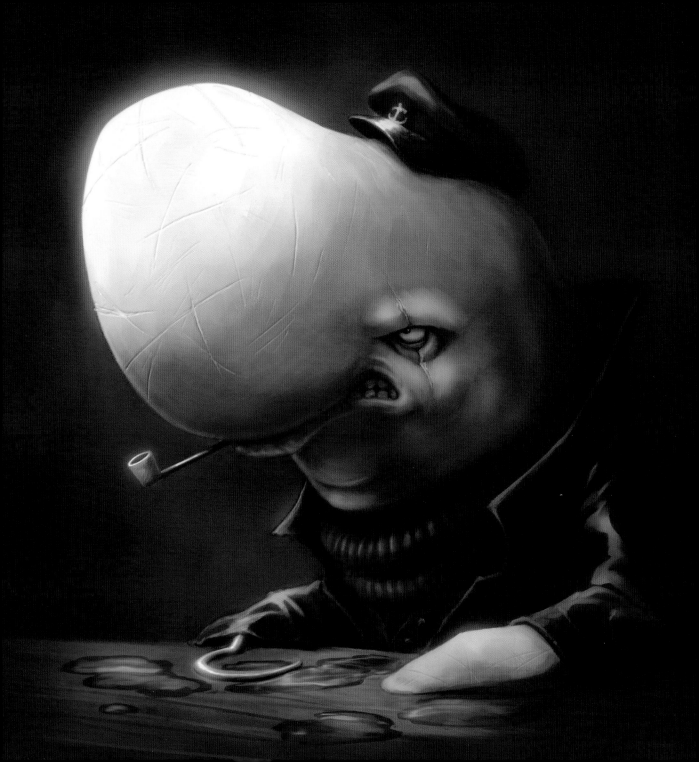

When they're not hibernating, bears are curious, playful, and active creatures. This one, however, is taking a moment's pause—perhaps to smell the roses (or would that be honey?), perhaps just to catch his breath. Something we *all* should remember to do from time to time.

## DAY 372 ▷

### Black Bear

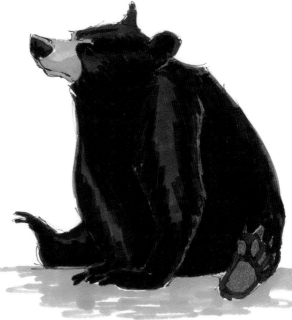

## DAY 378 ▽

### Porcupine with Rider

When I look at this sketch, just one question springs to mind: how on earth did that guy climb onto the back of a giant porcupine?

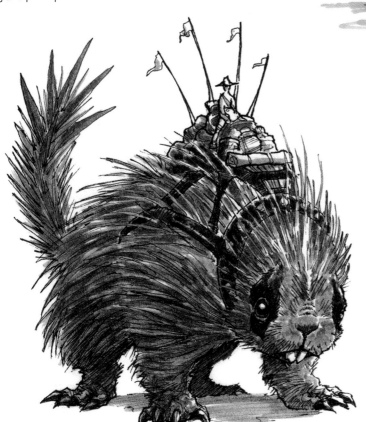

## DAY 373 ◁◁

### Moby Dick

Anyone familiar with Herman Melville's classic novel *Moby Dick* knows of Captain Ahab's quest for the great white whale. I suppose it can be a cautionary tale about letting a passion turn into an obsession. I absolutely love drawing; being both a job and a hobby it is a huge part of my life, sometimes to the point of crowding out other activities (frustrating my wife and friends on occasion!). But I try not to let that happen too often—if I were to become too one-dimensional, too focused on drawing, I think my art would eventually suffer. I need those other life experiences to provide fuel for my imagination.

## DAY 379 ▲

**Bridezilla**

Weddings were the theme of the day as Thasja and I spent the afternoon watching friends tie the knot before heading to a combined bachelor/bachelorette party for some other nuptially-minded friends later that evening. Following the afternoon ceremony, the bride made a joke about how proud everyone should be that she didn't have any "Bridezilla" moments. She was as calm and composed—and as un-Bridezilla—as any groom could hope. Not a single green scale, paralyzing glare, or smoking nostril could be found.

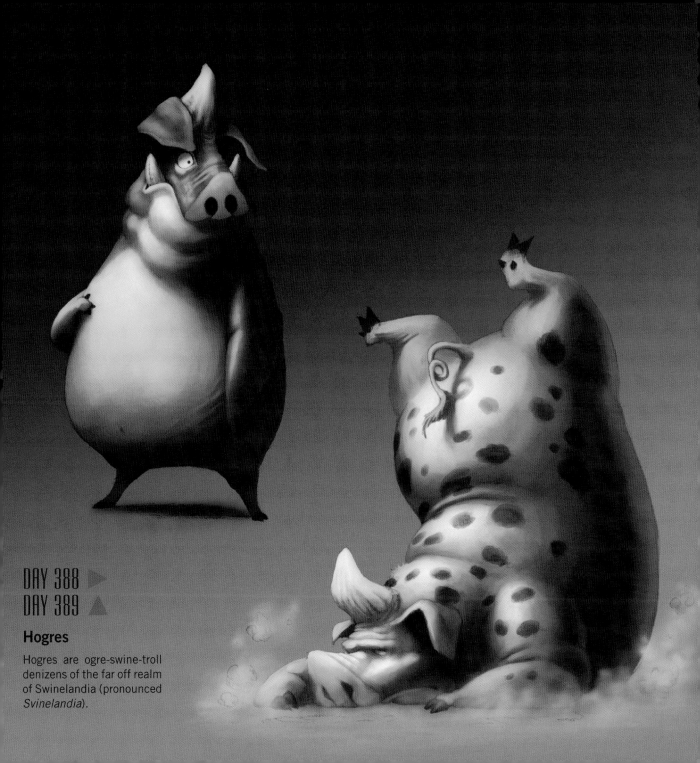

DAY 388 ▶
DAY 389 ▲

## Hogres

Hogres are ogre-swine-troll
denizens of the far off realm
of Swinelandia (pronounced
*Svinelandia*).

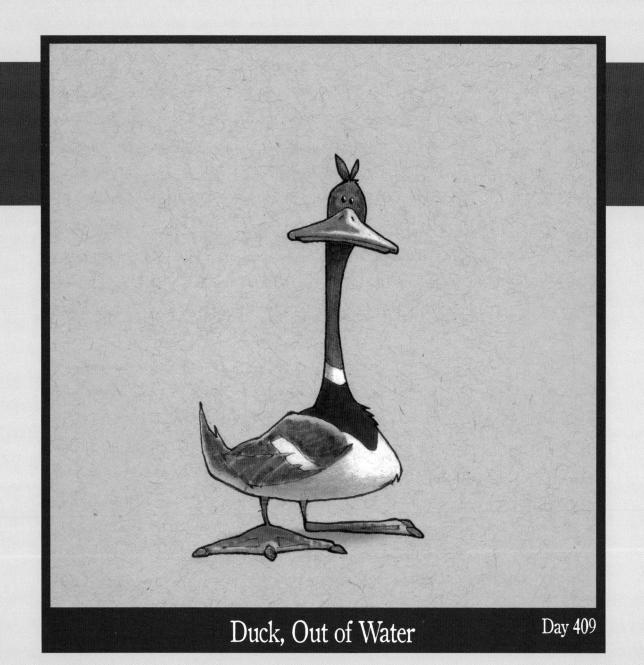

Duck, Out of Water          Day 409

# may 07

In the moments before my diagnosis, when I was in an exam room waiting for the hematologist to return from viewing slides of my blood, I was already out of my element. Up until this point I had been fortunate enough to rarely have been sick, and never seriously so. I was not used to spending time in a doctor's office, let alone a hospital. When the doctor returned and told me I had leukemia, I was *really* out of my element. I felt like a duck out of water. In an instant all the known comforts and safety of my existence B.C. (Before Cancer) were gone and I had been thrust into an ominous new world. The exam room hadn't changed, but the fluorescent lighting seemed a little harsher and the photos of penguin chicks adorning the walls suddenly didn't seem nearly so adorable.

Gradually the shock wore off and I became reluctantly more comfortable with the fact that I was now a cancer patient. Freshly hatched ducklings are pretty clumsy, especially on land, but in time they get it together. Adult ducks still aren't the most graceful of creatures when removed from the comfort of their pond, but they manage to do all right. Six weeks into my cancer journey, when I was checking back into the hospital for my second round of chemo, it was *slightly* less terrifying than the first time. There was still a great deal of uncertainty in the air, especially with the big question of my survival or demise, but many of the little things were more familiar and a little less scary. I knew some of the faces, knew some of the routine, and knew a little bit more of what to expect. I hope my cancer does not return, but if it does at least I can find a little comfort in the fact that now I'm a duck who doesn't always need water to feel at home.

Like many children, I was obsessed with dinosaurs while growing up. I still am to some extent. Immense variety in shape and size, along with the inherent mystery of not being able to see a living, breathing specimen is captivating. I drew dinosaurs, played with toy dinosaurs, read about dinosaurs, slept in dinosaur pajamas, drank from dinosaur cups, and probably on more than one occasion terrorized my younger sister with the fiercest T-rex impression that I could muster.

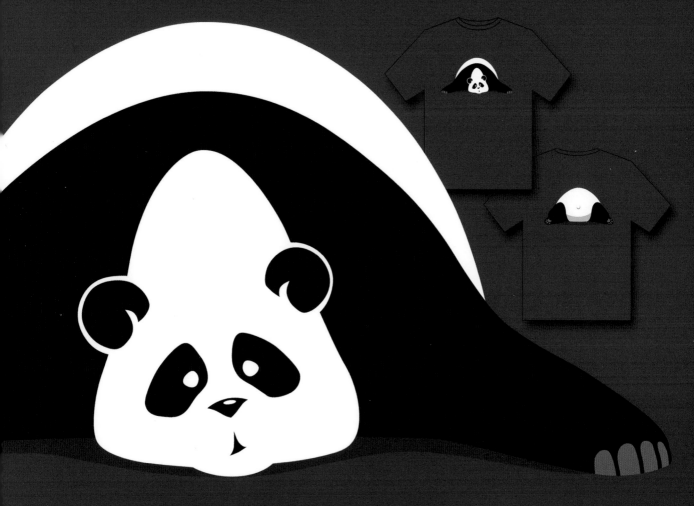

# DAY 399

## Panda Ker-plop!

I envisioned the panda on Day 399 as a fun t-shirt, printed on both front and back. A real panda's black and white coloration is already very bold and graphic, so it didn't take much to further stylize and simplify it. After scanning a pencil sketch, I made use of the vector art tools in Adobe Illustrator to give it the clean lines and even colors seen here.

# DAY 401 ◀

## She's Baa-aaack!

Izzie the Interstellar Ice Cream Vendor, a character I'm developing for a children's book, got the daily sketch treatment twice in the first *Daily Zoo* and now she and her cycloptic slug sidekick are back for more. It's not my conscious intention to play favorites, but I simply find that some animals or characters cry out for further visual exploration. I could say that combining a daily sketch with character design for another personal project is like killing two you-know-whats with one stone, but I wouldn't want to ruffle any feathers here at The Daily Zoo.

# DAY 405 ▲

## Visayan Warty Pig

Visayan warty pigs are one of the most critically endangered species of wild pigs in the world, surviving only on two islands in the central Philippines. Three sets of fleshy facial warts give these pigs their name, but it is the bristly Mohawk-like mane that males grow from forehead to rump during each breeding season that gives them their style! To my knowledge, the preference for striped shirts and suspenders is only evident in those residing in Southern California.

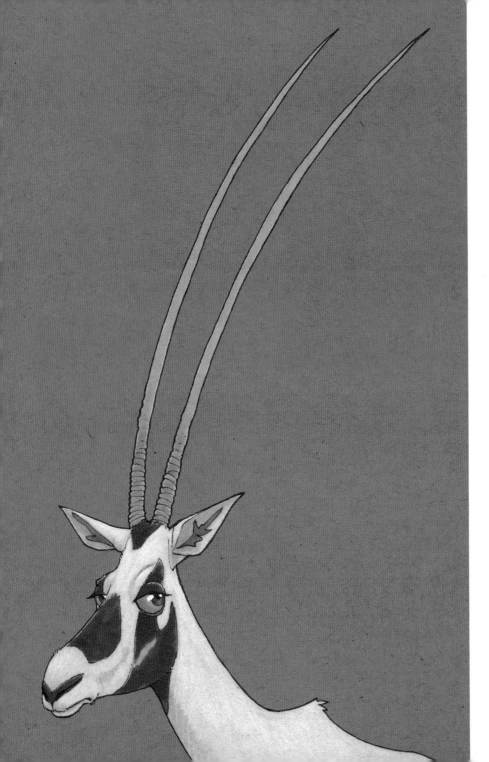

## Oryx

Many species of animals have adapted to living in extremely harsh and challenging environments. For example, the oryx, a large antelope native to the deserts of Africa and the Arabian Peninsula, has developed ways to conserve water including specialized kidneys and the ability to raise its body temperature up to 116° F. Only after that does it begin to perspire. Anyone dealing with a serious illness has to adapt too. When I was diagnosed with leukemia, many things in my life changed very quickly. I had very specific dietary restrictions. I was being poked, prodded, and inspected every four hours at the very least. I was tethered to an IV cart 24 hours a day and was confined to a single room and one long hallway for month-long stretches of time.

But I adapted. Friends and family spruced up the hospital room's décor with cards, posters, and even a life-size cardboard cutout of Darth Vader, who vigilantly watched over me from the corner of the room (and whose ominous silhouette alarmed the nurses more than once when they checked on me in the middle of the night). I learned which options from my limited menu were the safest choices to coincide with the chemo-induced nausea. I learned how to sleep relatively comfortably without tangling my many IV lines. Even now, being in remission, I've had to adapt to the idea of being a cancer survivor as I discover new limitations and differences in my life outlook from my pre-cancer days.

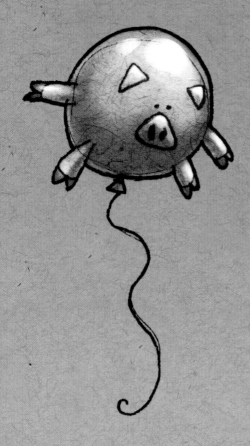

# DAY 407 ▲

## Inflatable Porcine Child Entertainment Device

I guess they *can* fly!

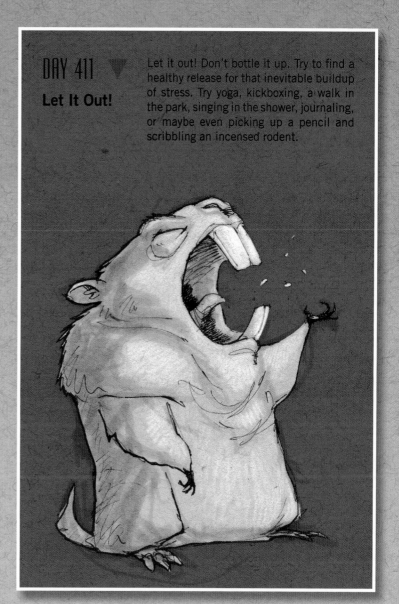

# DAY 411 ▼

## Let It Out!

Let it out! Don't bottle it up. Try to find a healthy release for that inevitable buildup of stress. Try yoga, kickboxing, a walk in the park, singing in the shower, journaling, or maybe even picking up a pencil and scribbling an incensed rodent.

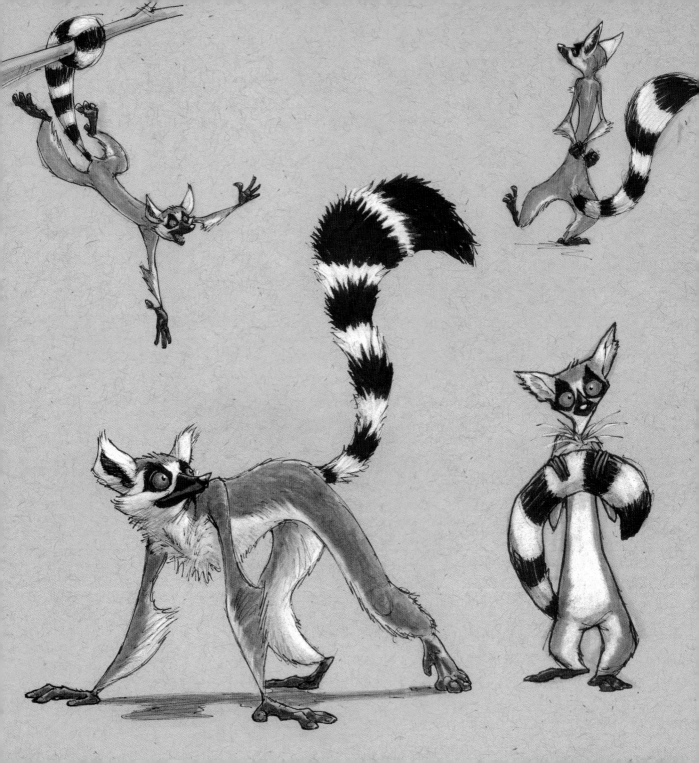

## Lemur Love

When I was in college, our family purchased a used car which came with a bumper sticker that proclaimed, in no uncertain terms, a great affinity for these beautiful creatures: "I ❤ lemurs." On Day 417, I drew the larger lemur at bottom left. The following day I chose to stay with this particular species, the ring-tailed lemur, but to explore a more anthropomorphic approach. As for the origin of the unusual bumper sticker, the car's previous owner had lived in North Carolina near the Lemur Center at Duke University, which houses the largest collection of pro-simians outside of their native Madagascar and also serves a key role in both conservation and research.

DAY 419 ▶

## "Squint!"
## Said the Chimp

On Day 419 I wasn't in the mood to draw anything with a lot of detail, but chimpanzee faces have exactly that, a lot of detail: abundant wrinkles, wide lips, deep-set eyes, wiry hair, complex nostril and ear structures…. Since that was the reference material I happened to have in front of me, I decided to take a more simplified approach. While looking at the picture I squinted my eyes to minimize much of the detail and simply focus on seeing the broader shapes of lights and darks. I then drew in "high contrast mode" by outlining the shadows with simple contours and then filling them in with a black marker. Squinting—it's not just good for ruining a yearbook graduation photo, it's also useful for viewing an image's overall value structure.

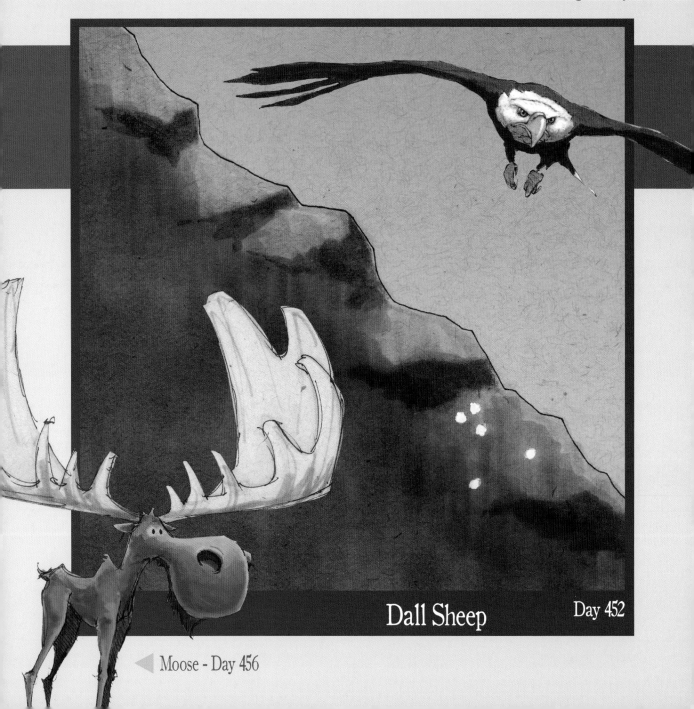

Dall Sheep

Day 452

# june 07

It can take a while to get back in the saddle of life once something like cancer throws you off. There are of course the physical wounds to heal, but the mental wounds can be just as deep, if not deeper. Once in remission and on your way to recovery, it is certainly understandable to be filled with a newfound zest for life. It is also natural to be filled with a lot of uncertainty and fear. Will the cancer come back? What will I do then? Thoughts like these can impede your ability to make or have any confidence in long-term plans. Should I buy a house? Should I pursue a new career? What about getting married or starting a family?

The first year of The Daily Zoo was important to me in this regard because it was a long-term goal. Consciously, I was quite unsure about my future and cautious about being overly optimistic that the cancer was gone for good. But on a subconscious level, challenging myself with the prospect of drawing an animal a day for a year meant that I wasn't planning on punching out my final timecard just yet. It was extremely helpful to my healing and overall state of mind to have a long-term plan in place.

On a family vacation to Alaska in June 2007, almost two years into remission, I made another long-term plan when I got down on one knee on the shore of Horseshoe Lake, just outside Denali National Park, and asked Thasja to be my wife.

Sea Otter - Day 454 ▶

## Wilford

This fellow was inspired by Wilford Brimley's character in the Ron Howard film *Cocoon* which I had recently watched again. His big, bristly mustache screamed, "Walrus!" to me. The film involves a group of Florida octogenarians who happen upon a swimming pool filled with extraterrestrial pods that give off "youthifying" energy. After a few dips in the pool, the old-timers are enjoying the zest of living as if they were in their twenties. Unfortunately, we can't all be so lucky as to have a close encounter of the aquatic kind. Most of us have to stay young at heart the old-fashioned way: living life with laughter, love, and lightness.

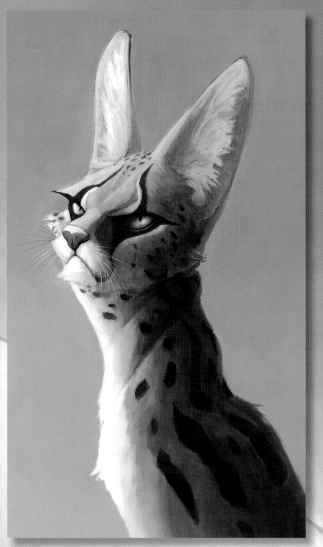

## DAY 444 ▼

### Harpy Eagle

Harpy eagles are near the top of the food chain in the tropical rainforests of Central and South America. For such large birds they have relatively small wings which allow them maximum maneuverability as they pursue their prey through the tree canopy. Their name comes from the Greek mythological creature which combined the face of a human and the body of a bird, usually a vulture or eagle.

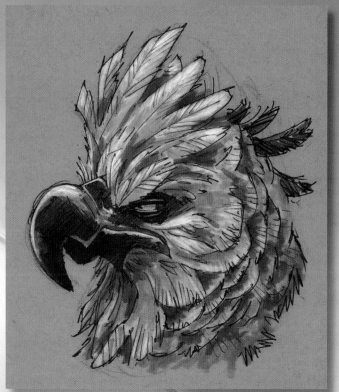

## DAY 435 ▲

**Serv*al*,
Not Serv*ant***

This serval's expression of nonchalant-yet-knowing superiority reminds me of the old saying, "Dogs have owners, cats have servants."

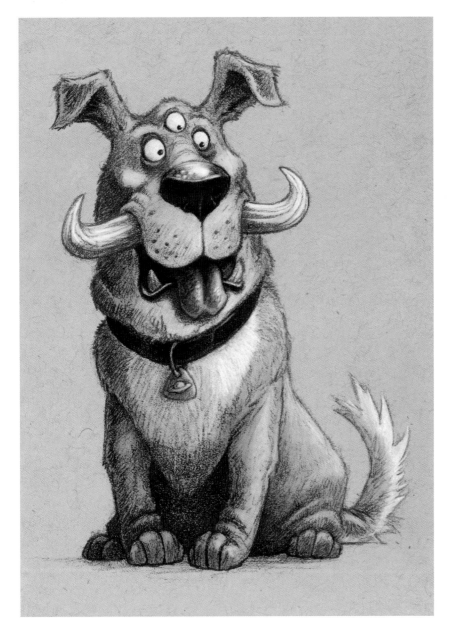

# DAY 447 ◀

## A Martian's Best Friend

Now *this* is a dog I could envision being called "Pluto." He's a rare Yellow Labrador and Tusked Gundarian Retriever mix, all the rage at the poshest dog parks in the Outer Galaxies.

# DAY 448 ▶

## Golden Langur

As you might guess, I enjoy going to zoos. While it's unfortunate that the residents are in captivity, the sad reality is that the human race has done a poor job of sharing Planet Earth with our animal neighbors. We have destroyed and polluted much of their natural habitat, killed them as "pests," and exploited them for food and other body parts at unsustainable levels. The golden langur, known for its rich golden or cream-colored coat of hair, is one of the most endangered primates in India. Until we get our act together, the safest place for many species will soon be in a zoo.

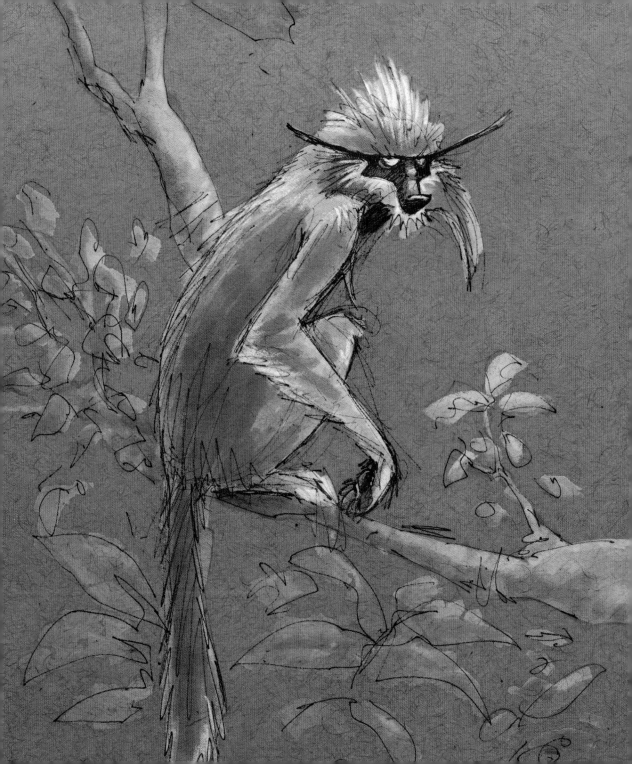

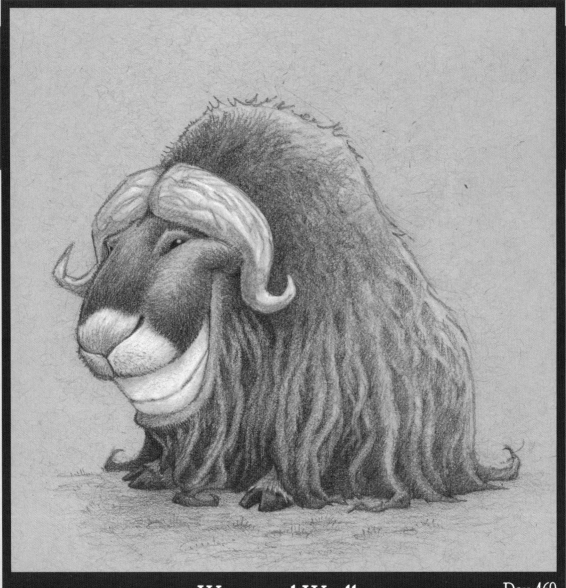

Warm and Woolly

Day 469

# july 07

Every day of every month is an opportunity to express my gratitude for the fact that after battling a life-threatening disease I am here and I am healthy. The month of July, however, is extra special. I received my autologous stem cell transplant in early July 2005, which the nurses called my "new birthday." My traditional birthday happened to be a few weeks later, so I am one of the few people lucky enough to celebrate two birthdays in a single month!

In many ways I view my experience with cancer as a gift. Granted, it is easier to have that view when things have turned out as well as they have. It was a physically and emotionally painful journey, but it strengthened my relationships with the community of people around me and introduced me to a slew of amazing new people as well. I am also grateful for my passion for art. I feel so fortunate that I can turn on that inner faucet of joy and find excitement, adventure, and solace using just a pencil, paper, and a dash of imagination.

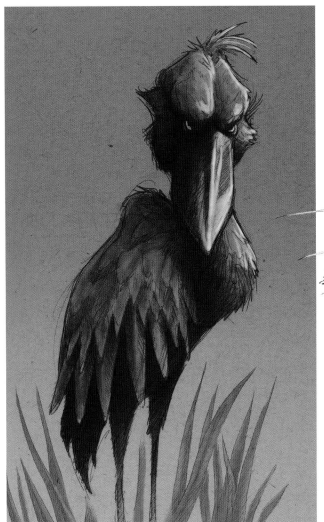

## DAY 460 ◀

### Shoebill

While the shoebill is very aptly named, I prefer its taxonomical Latin name, *Balaeniceps rex*, which translates into the Whalehead King!

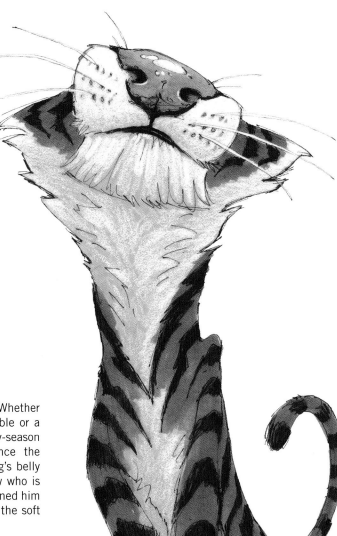

## DAY 466 ▶

### Content Kitty

It's wonderful to see an animal content. Whether witnessing young chimps frolic and tumble or a herd of elephants play and spray in a rainy-season watering hole, watching them experience the simple joy of the moment is infectious. When rubbing a dog's belly or hearing a cat softly purr in your arms, it's tough to know who is enjoying it more, you or them. While drawing this tiger I imagined him with a full belly, basking in the sun before settling down in the soft grass for an afternoon snooze.

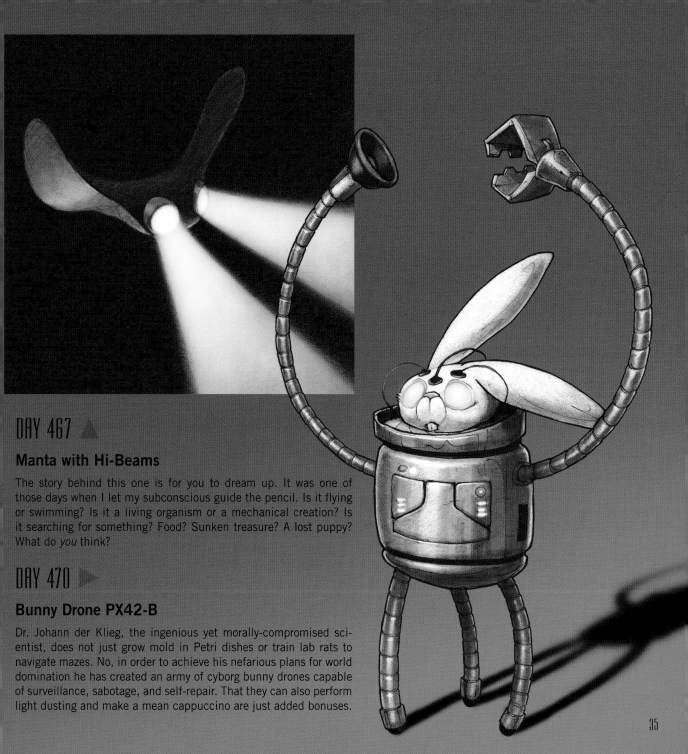

# DAY 467 ▲

## Manta with Hi-Beams

The story behind this one is for you to dream up. It was one of those days when I let my subconscious guide the pencil. Is it flying or swimming? Is it a living organism or a mechanical creation? Is it searching for something? Food? Sunken treasure? A lost puppy? What do *you* think?

# DAY 470 ▶

## Bunny Drone PX42-B

Dr. Johann der Klieg, the ingenious yet morally-compromised scientist, does not just grow mold in Petri dishes or train lab rats to navigate mazes. No, in order to achieve his nefarious plans for world domination he has created an army of cyborg bunny drones capable of surveillance, sabotage, and self-repair. That they can also perform light dusting and make a mean cappuccino are just added bonuses.

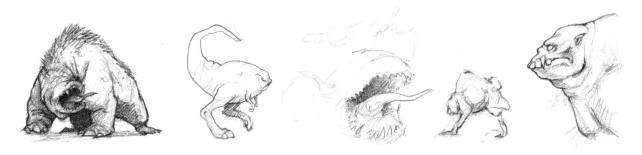

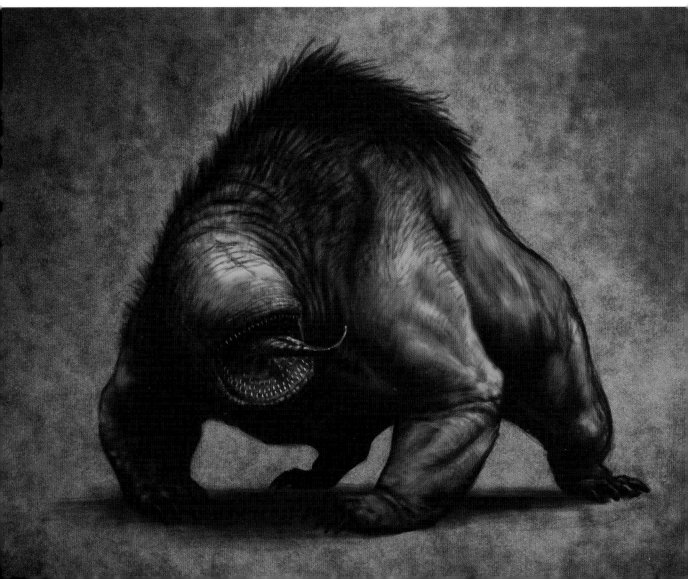

# DAY 474 ◄

## Monster Bear

The creation and ongoing maintenance of a strong portfolio is an essential part of being a successful freelance artist. Unless you are a household name resulting from a large and storied body of work, which most of us are not, potential clients and employers need to see your capabilities. The bulky bear-like creature on the facing page originated from a set of small thumbnail sketches done on Day 474. I was updating my portfolio and wanted to include a few additional examples of more realistic creature work, so I took one of the more promising thumbnails to a further state of finish.

# DAY 479 ►

## The Solemn Order of the Black and White

A blend of Chinese fauna and Japanese Samurai culture. Just for the record, I did this *before* seeing *Kung Fu Panda!* This warrior reminds me of my good friend Karen, also a cancer survivor. She prefers the term "Cancer Conqueror," which I think is great. We toast our thus-far successful campaigns of conquest with champagne each time that we see one another.

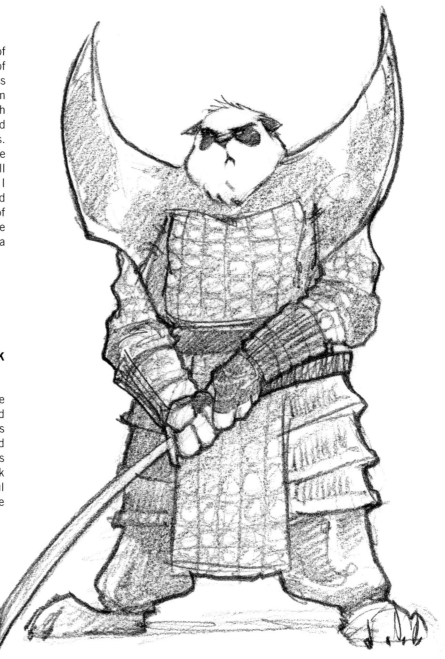

## DAY 480 ◄

### Paint-by-Lasso

I had seen work by other artists that had been created on the computer solely by using the "lasso" tool in Photoshop and I wanted to try it out for myself. The lasso tool allows you to easily draw freehand shapes and fill them with solid color. I referenced a photo of an energetic Sumatran tiger cub that I had snapped at the Los Angeles Zoo but did all the drawing freehand. My mom said it reminded her of a paint-by-numbers kit—*gasp!*—which I can understand, but it was still fun to experiment with a new tool and technique. I guess if the film work ever dries up, I can always create paintings for cheap motels.

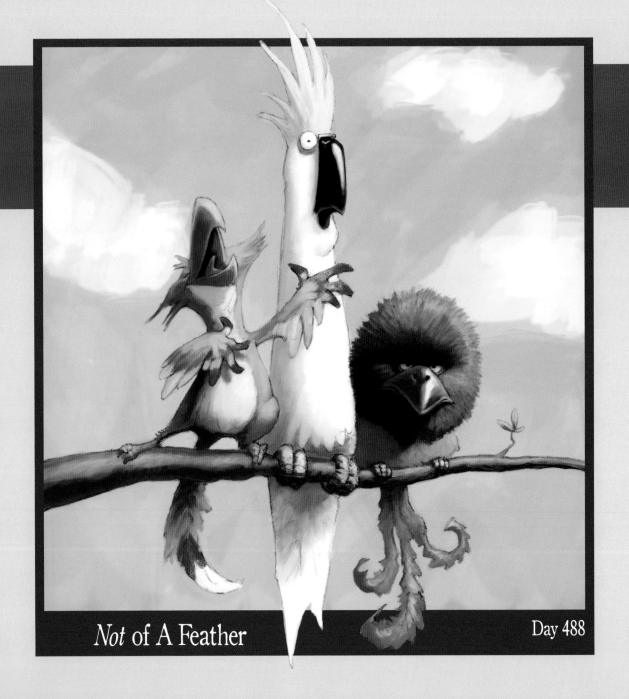

*Not* of A Feather

Day 488

# august 07

In the first *Daily Zoo* I wrote about how each cancer patient is different. Each one of us has a unique medical history, genetic background, and life experiences that play a role in our fight. There are, however, many similarities in our cancer journeys, in terms of both treatment and recovery. One of the humbling aspects of publishing *The Daily Zoo* has been the depth to which other patients and survivors connect with it. I was just trying to tell my story, but what I didn't realize was how many others had a very similar story to tell.

This hit home again recently when I read a speech by Kaitlin, a fellow cancer survivor, which she had given the night before she participated in a Team in Training triathlon. I could identify with many of her experiences, thoughts, fears, reactions, and humor. It felt almost as if she was telling *my* story. Sharing one's story and listening to the stories of other survivors can be very cathartic and I encourage patients, survivors, and caregivers everywhere to seek out support groups or survivor events for some heartwrenching and heart*warming* storytime.

# DRY 493 ▲

## Saggy Bunnies

I drew these rabbits on a hot, sticky August evening. Not being sure of what to draw, I glanced around our apartment and spotted Thasja's stuffed animals. The appeal of their round, bottom-heavy shapes, combined with the day's draining weather, resulted in a group of exhausted bunnies, sinking—almost melting—into the ground under the weight of a hot and humid summer's day.

# DRY 491 ▶

## Bold and Beautiful!

While sketching at the zoo, I like to listen to the comments of other visitors as they watch the animals. At the enclosure housing the babirusa, a type of wild Indonesian pig, I hear a lot of, "Ewww! They're soooooo ugleeeeee!" Sure, their saggy, wrinkly skin; large, protruding tusks; and flexible, wet snout wriggling along the ground in search of a meal may not fall into the category of what we typically think of as cute or attractive, but I see real beauty there...which I'm sure my wife will remind me of when *she* is saggy, wrinkly, and has large tusks.

## Antoni the Eccentric Hermit

For her 29th birthday, my sister Colleen requested a "hermit crab with an architecturally-elaborate shell" for The Daily Zoo. I've long admired the organic and fluid style of the late 19th century Spanish architect Antoni Gaudi, so I pulled a book of his work off the shelf and browsed before starting to draw. His flowing shapes and use of embedded mosaics remind me of giant sand castles decorated with sea shells so it seemed fairly logical to incorporate those elements within the shell of a coastal crab.

# DAY 507 ▼

## Baron Von Woof

The Baron is a self-absorbed, crotchety, old wolf who lives by himself in Blackridge Manor up on Old Rottingham Hill. On the rare occasions that he invites some of the townsfolk up to his house for tea, they suffer through the long-winded and exaggerated tales of his life escapades only because the crab cakes and cucumber sandwiches are so divine.

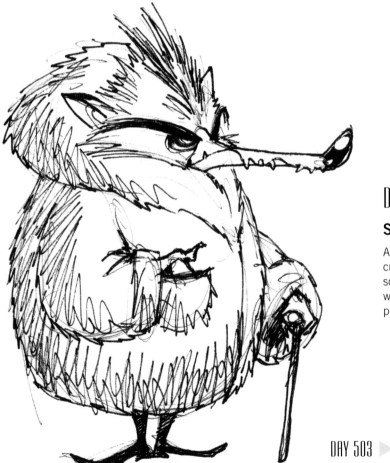

# DAY 497 ▲

## Scribblemaus

Another technique I periodically use to get the creative juices flowing is to draw a quick random scribble on the paper and search for a character within those shapes and lines. That's how this pensive rodent came to be.

# DAY 503 ▶

**Arachnerd**

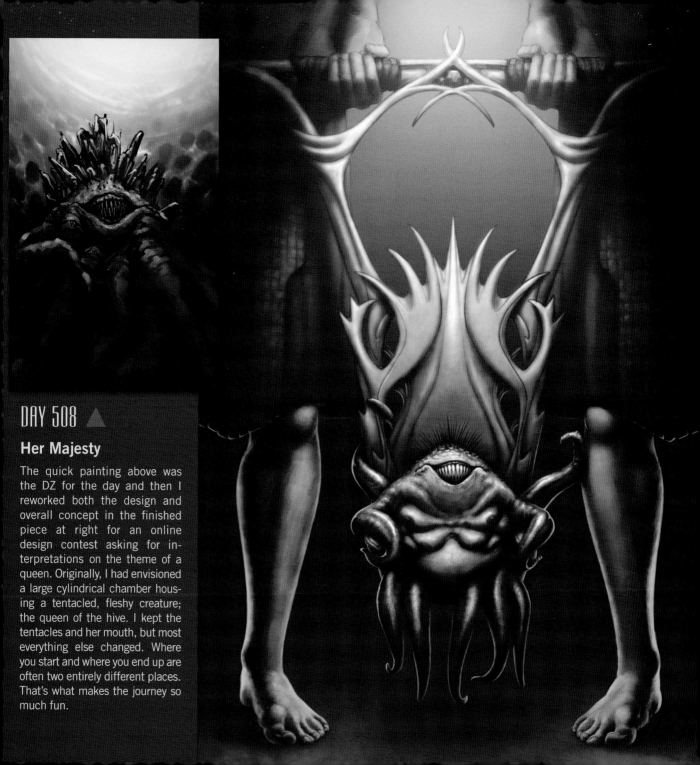

## DAY 508 ▲

### Her Majesty

The quick painting above was the DZ for the day and then I reworked both the design and overall concept in the finished piece at right for an online design contest asking for interpretations on the theme of a queen. Originally, I had envisioned a large cylindrical chamber housing a tentacled, fleshy creature; the queen of the hive. I kept the tentacles and her mouth, but most everything else changed. Where you start and where you end up are often two entirely different places. That's what makes the journey so much fun.

## DAY 516 ▲

### Sticky-Note Gnu (actual size)

This was drawn at Design Studio Press, my publisher, while I was waiting for files to download—*very slowly*. Sketching a gnu, or wildebeest, who is pushing and straining against the edge of the paper didn't make the download go any faster, but it did take care of the Daily Zoo for the day.

## DAY 517 ▶

### Gnu Part Deux

I admit it. I was feeling a little sheepish that the previous day's sticky-note gnu was so small and quick, a doodle really. I shouldn't have been, however, because not every day's sketch has to be a lengthy, involved piece. One of the core concepts of The Daily Zoo is to do something creative every day, no matter how small or simple. Still, I wanted to revisit the subject matter, this time with a little more love and attention. I try not to pressure myself into coming up with something completely new every day. Some days it is a continued exploration of a previous idea, technique, character, or animal.

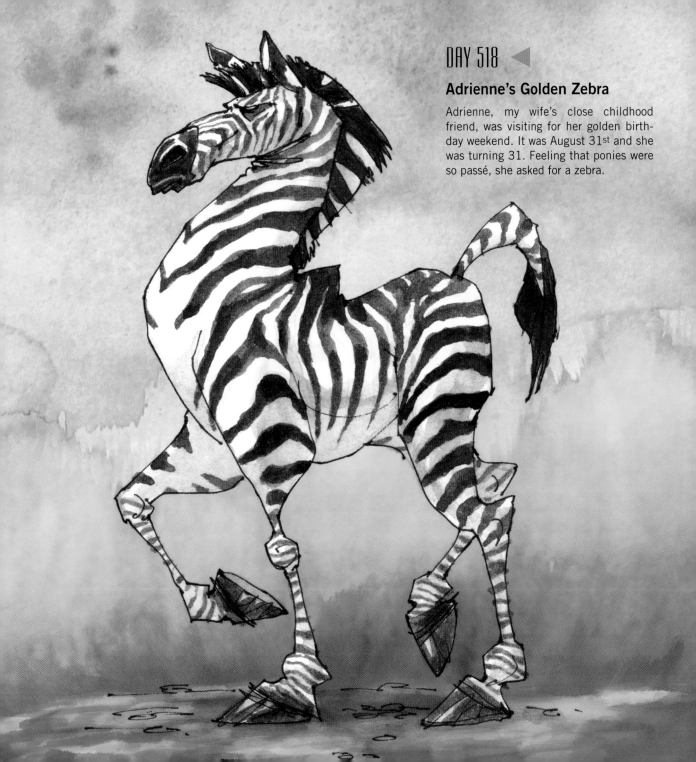

## Adrienne's Golden Zebra

Adrienne, my wife's close childhood friend, was visiting for her golden birthday weekend. It was August 31st and she was turning 31. Feeling that ponies were so passé, she asked for a zebra.

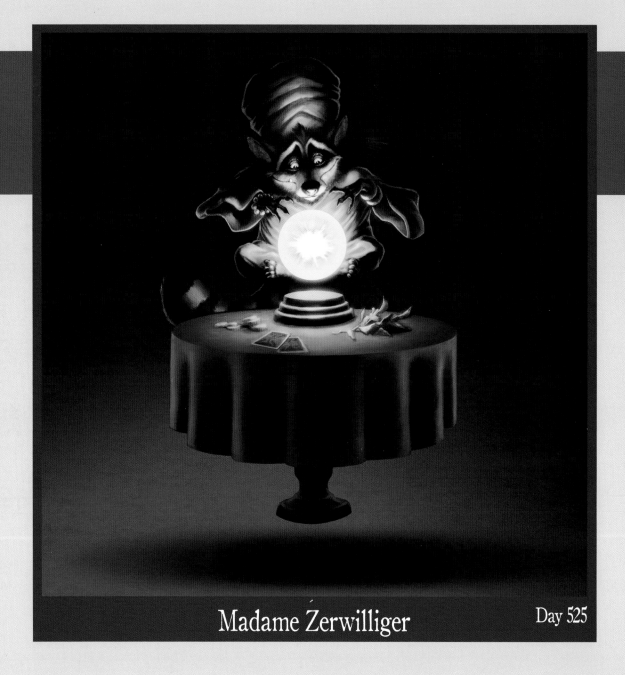

Madame Zerwilliger

Day 525

# september 07

Not many of us possess a crystal ball—or at least one that works (and no, Magic Eight Balls don't count). The Future, that amorphous and ever-changing cloud billowing with hope and possibility as well as the unknown, always dangling in front of us just out of our grasp, is uncertain for all of us. For a cancer patient, however, that future can feel even more uncertain. Looking into that cloud while battling or recovering can seem especially dark and ominous. How do you cope with that? Personally, I do my best to live one day at a time and not fill my brain with worry for what may lie ahead. If I'm thinking too much about tomorrow, it's harder to enjoy today.

Save room to be surprised. Life has a lot to offer, much of it delightfully unexpected. I strive to keep my mind and senses open to discover new sights, sounds, tastes, smells, textures, and adventures. It's important to have clear goals but I try not to let myself become so fixated on a single path ahead of me that I miss all of the fantastic scenery along the way. I don't want to skip ahead to the last page and find out how my story ends. For better or for worse, I'd like to be surprised.

## DAY 523 ▼

### Smitty the Smoggy

Smitty was drawn one afternoon while I was waiting for my car to have its periodic smog check. A woman who was also waiting saw me sketching and asked to see it. Perhaps because I was drawing an elephant, which happens to be the official mascot of the Republican party, our conversation led to a discussion of the presidential primaries which were about to occur. Often when I'm drawing in public places such as food courts, zoos, or airports, people approach me or watch over my shoulder. I don't mind and it can be a conduit to meeting some very interesting people.

## DAY 519 ▲

### Coati

When I was 8 or 9 years old I had a small, tattered copy of *Mark Trail's Guide to North American Mammals*, which was filled with numerous black and white illustrations. That was probably the first time I learned about coatis, members of the raccoon family that range from the southwestern U.S. to central South America. I think I must have drawn every animal in that book—some of them many times over. I also checked out how-to-draw books from the library and spent hours copying favorite panels from comic books and the Sunday funnies. While I've outgrown line-for-line copying, as a beginning artist it helped me hone my skills of observation and gave me hours of enjoyment and practice with pens and pencils.

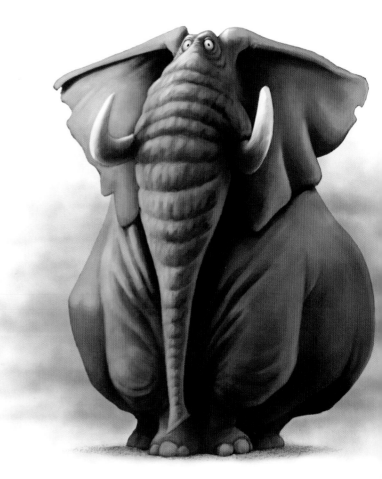

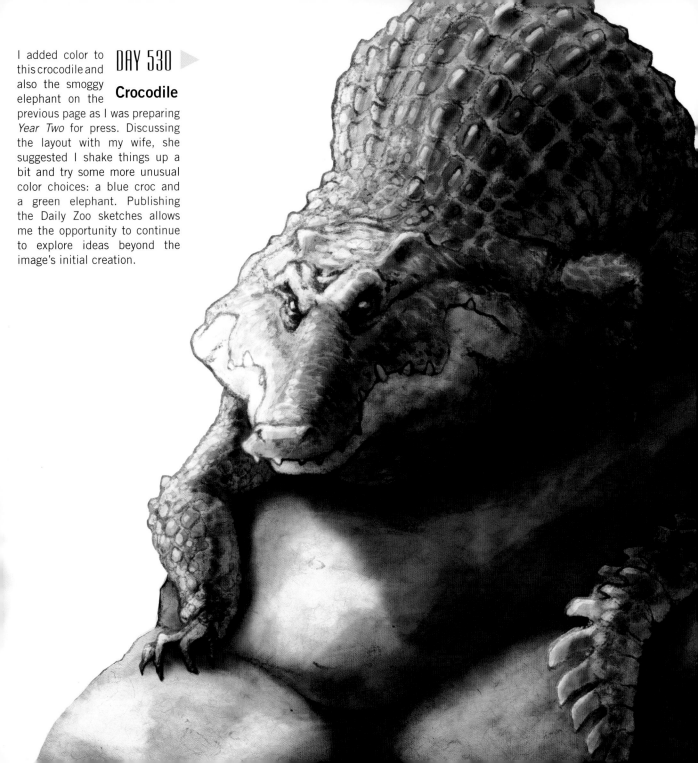

I added color to this crocodile and also the smoggy elephant on the previous page as I was preparing *Year Two* for press. Discussing the layout with my wife, she suggested I shake things up a bit and try some more unusual color choices: a blue croc and a green elephant. Publishing the Daily Zoo sketches allows me the opportunity to continue to explore ideas beyond the image's initial creation.

# DAY 530 ▶

## Crocodile

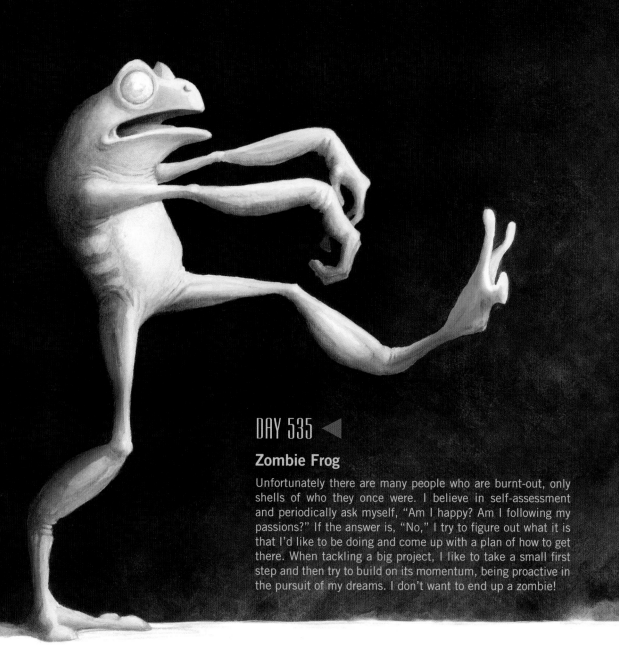

## DAY 535 ◄

### Zombie Frog

Unfortunately there are many people who are burnt-out, only shells of who they once were. I believe in self-assessment and periodically ask myself, "Am I happy? Am I following my passions?" If the answer is, "No," I try to figure out what it is that I'd like to be doing and come up with a plan of how to get there. When tackling a big project, I like to take a small first step and then try to build on its momentum, being proactive in the pursuit of my dreams. I don't want to end up a zombie!

## DAY 536 ▶

## The Maned Skelm

This beaked quadruped lives a solitary life
roaming the misty moors of Kilklach.

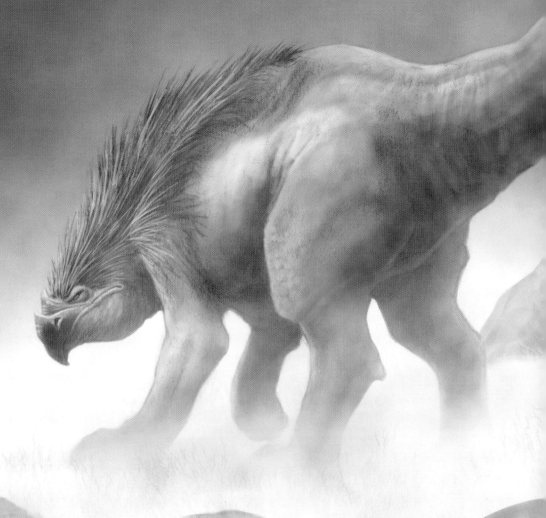

53

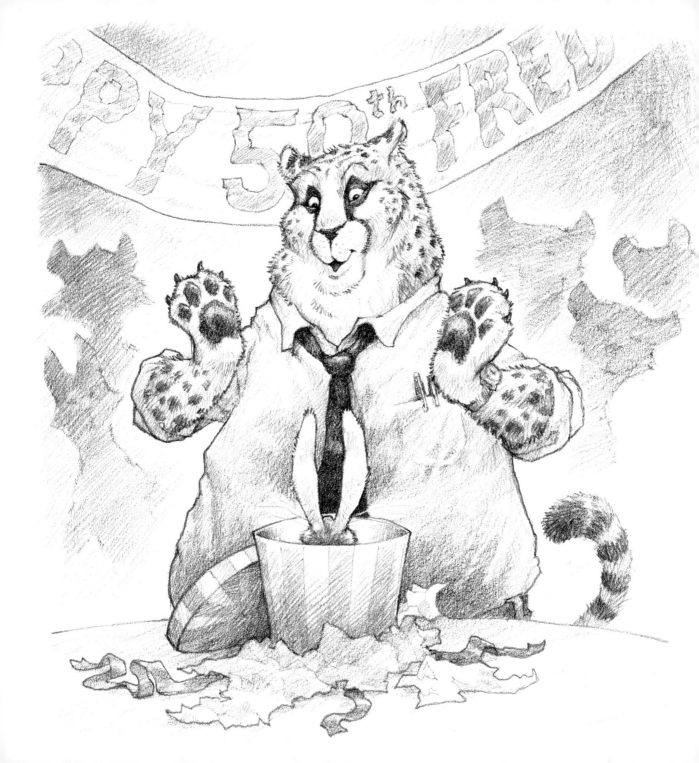

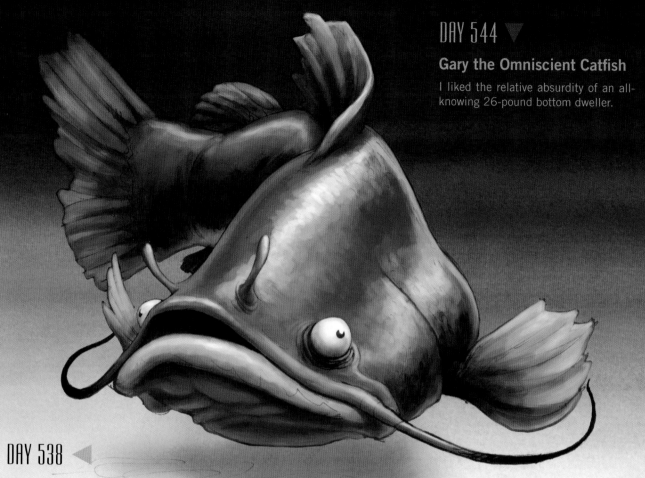

## DAY 544 ▼

### Gary the Omniscient Catfish

I liked the relative absurdity of an all-knowing 26-pound bottom dweller.

## DAY 538 ◄

### Fred Turns Fifty

Immediately after completing this sketch, I jotted down the stream-of-consciousness description of my creative thought process: "This one evolved as I drew it. Started out as a cheetah...they're such slender, sleek, graceful animals—why not go in the opposite direction? What is he wearing? If he's got a lot of girth he's probably not chasing down prey on the savanna...maybe he just drives to the QuickieMart down the street for his meals...maybe he lives in the suburbs and works as a data systems analyst or an insurance salescat or something...maybe he's opening a box...a present. What would excite a predatorial big cat? Oops, but cheetahs are "small cats" since they can only purr and not roar; "big cats" can only roar and not purr...What about a cute little bunny? Is it to eat? A new pet?...Presents lead me to birthdays...he's middle-aged...let's make him be turning 50...f-ffff...Fred. That's a good suburban, somewhat nondescript name—apologies to all the Freds out there!..."Fred Turns Fifty"... Let's add a banner...and unfortunately—because I'm tired and ready to end this sketch—to sell the idea of a party you need some guests...though let's keep them in silhouette to keep the focus on Fred and again, because I'm tired...but definitely make them feline silhouettes...okay, done. I would not want to be that bunny."

55

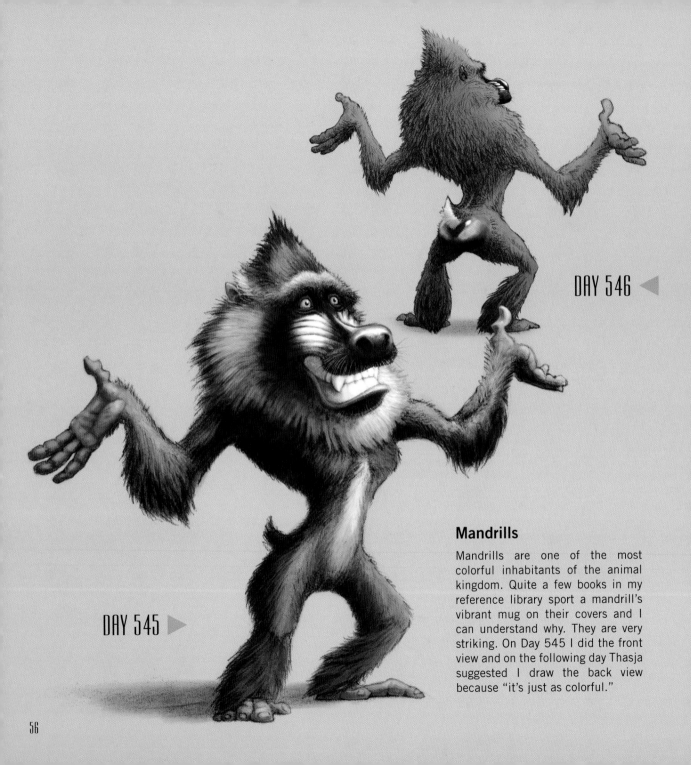

**DAY 546** ◄

**DAY 545** ►

## Mandrills

Mandrills are one of the most colorful inhabitants of the animal kingdom. Quite a few books in my reference library sport a mandrill's vibrant mug on their covers and I can understand why. They are very striking. On Day 545 I did the front view and on the following day Thasja suggested I draw the back view because "it's just as colorful."

## Powder Blue Pig

Sometimes it can be fun to explore familiar
subject matter by using unfamiliar or
unexpected colors choices.

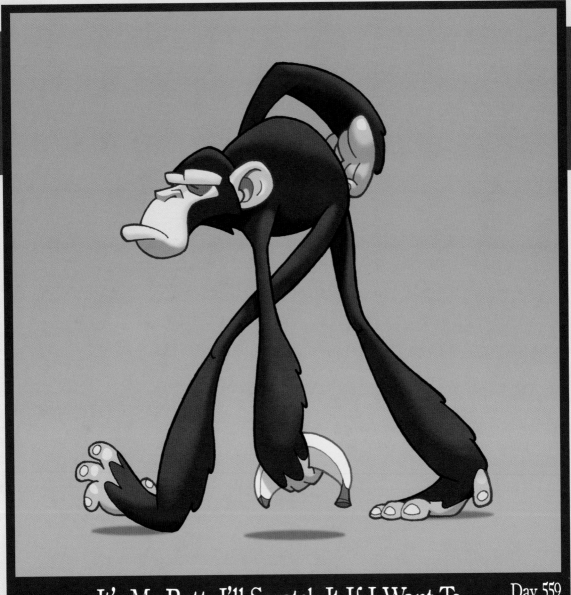

It's My Butt, I'll Scratch It If I Want To

Day 559

# october 07

Most people who know me would probably agree that I'm not a vain person. I tend not to get caught up in superficial appearances. Still, it was a challenge adjusting to the physicality of being a cancer patient. Hospitals should really have a big collection bin at the front door labeled "Drop Your Pride Here" because as you begin treatment that is one of the first things to go—followed shortly by your hair. As a patient it seems as if parts of you are constantly being poked, extracted, biopsied, tested, inspected, sliced, stitched, swabbed, squeezed, palpated, and listened to. I dealt with hair loss, weight loss, bad breath, peeing into a bottle for months, stool samples, mucous samples, loss of bladder control, and dropping my pants in the middle of the night in front of a urologist to investigate a possible urinary tract infection. Perhaps the worst was not being able to wear contact lenses, instead being forced to sport my big blue-rimmed glasses from high school. But you know what? None of that mattered. Your physical appearance and privacy become so unimportant. It was the last thing on my mind. First and foremost I just wanted to *feel* better. I could care less if someone caught a glimpse of London, France, or my underpants.

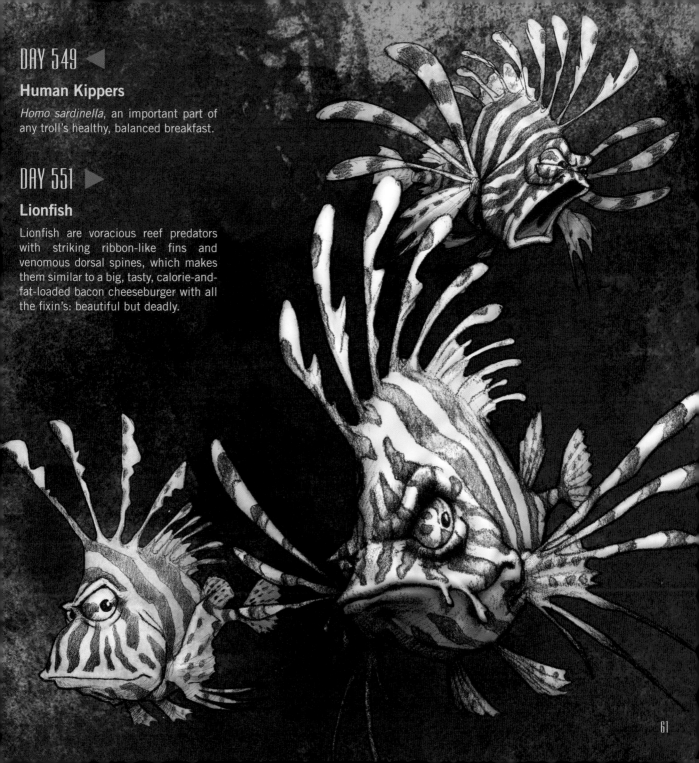

# DAY 549 ◄

## Human Kippers

*Homo sardinella*, an important part of any troll's healthy, balanced breakfast.

# DAY 551 ►

## Lionfish

Lionfish are voracious reef predators with striking ribbon-like fins and venomous dorsal spines, which makes them similar to a big, tasty, calorie-and-fat-loaded bacon cheeseburger with all the fixin's: beautiful but deadly.

## DAY 552 ◄

### Warthog

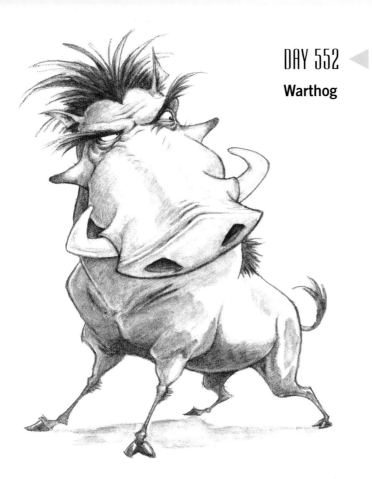

## DAY 555 ►

### Rhino

While watching Disney's *Mulan* one evening, I was inspired by the wonderful character designs which made beautiful use of flowing, simple shapes. For the day's sketch I attempted to mimic some of that fluidity and to translate it to one of my favorite animal subjects: the indomitable rhinoceros.

## DAY 553 ►

### Capuchin Conductor

I believe that being a visual artist is akin to being a musical conductor. You give the sheet music (the brainstorm, concept, story...) to the orchestra (the tools: pencils, paints, paper, canvas...) and lead them in rhythm, melody and flow (proportion, composition, hue, value, balance...) to achieve a beautiful, arresting, moving, emotional experience (hopefully fantastic images!). Perhaps the only difference is that I can conduct my "orchestra" in my pajamas rather than a tux.

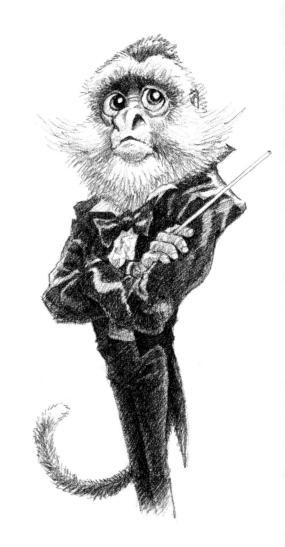

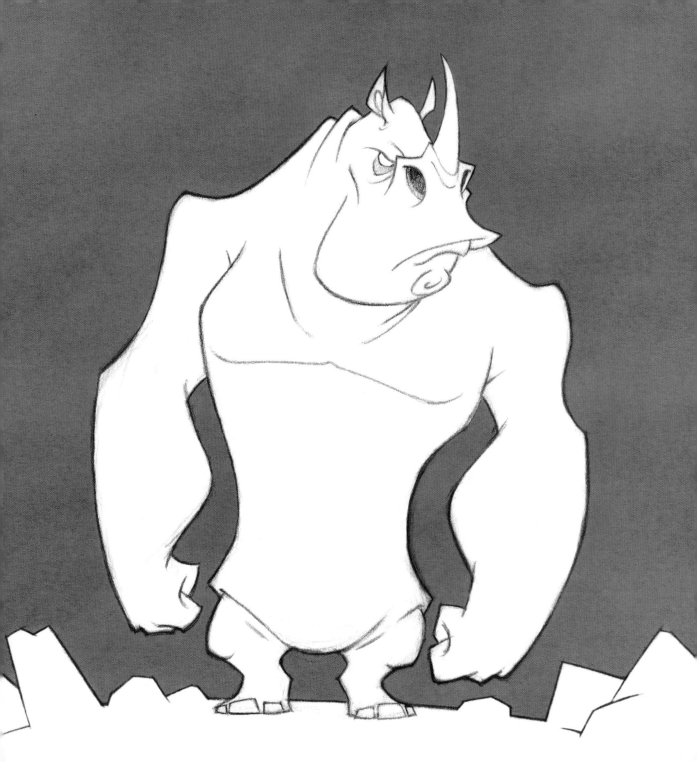

## Colonel Astrellis

Sala Astrellis, a colonel in the Royal Atmospheric Defense Force, relaxes at the local watering hole after returning from a routine patrol circuit around the outer wastelands. While browsing through a book on Africa, I discovered a picture of two lionesses nuzzling one another. It kind of squished one of their faces and gave it a tired, haggard look. I envisioned her as a veteran hunter and mother, an old soul who had seen a lot during her time on the savanna. That in turn spurred the idea of a decorated pilot slouching in the corner of a futuristic cantina.

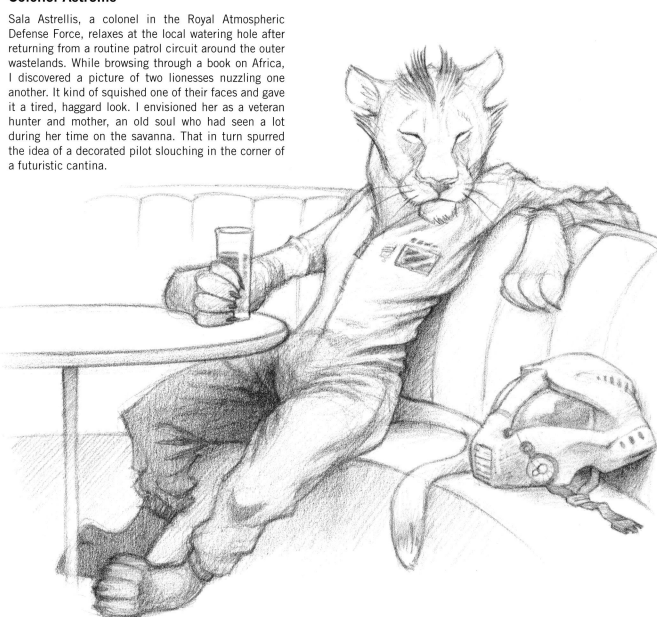

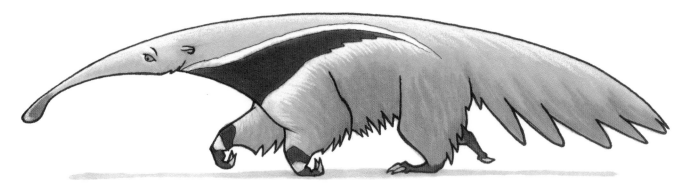

# DAY 557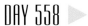

## Anteater Arc

One of the highlights for me when I visit the San Diego Zoo is the giant anteater, mainly because I haven't had that many opportunities to observe them in person since they are not often found in captivity. They are native to the grasslands of South America and are one of the few animal species that walk on their front knuckles. The giant anteater's tongue, which can extend up to two feet in search of tasty ant morsels, is rivaled only by that of Gene Simmons. For this particular anteater I exaggerated and combined the curves of his snout, back, and tail into one long, nearly symmetrical arc.

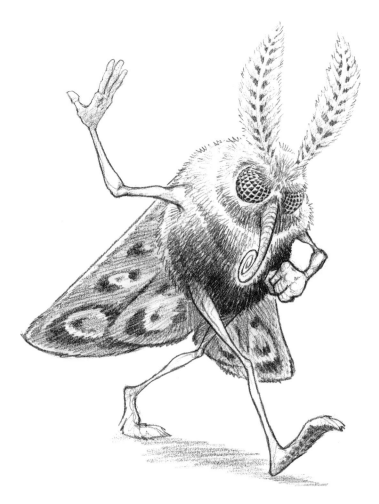

# DAY 558 ▶

## Talk to the Hand

Mr. Feldspar has heard enough. He's going home.

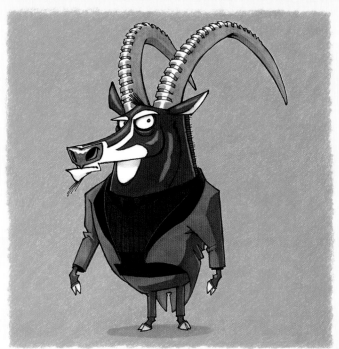

## DAY 561 ▼

### Rhino Plumber

Because I had enjoyed the overall body shape and proportions of the Mayor so much, I decided to stick with it on the following day and drew that rhino after all. I couldn't help myself! Their multitude of great shapes and textures make them irresistible to sketch. I can envision an entire town populated with these squat, skinny-legged characters representing various species. I'll have to add it to the ever-growing list of future projects. As great as The Daily Zoo has been for idea generation, one of the drawbacks is that I've got more characters than I know what to do with and not enough time to tell all their stories!

## DAY 560 ▲

### Mayor Neighs

The squat, barrel-shaped body of Mayor Neighs was inspired by one of the characters—also a mayor—in Tim Burton's film, *The Nightmare Before Christmas*, which I happened to watch on this day. My first inclination was to draw him as a rhino, but then I thought, "You do plenty of rhinos! What would be something different?" That's when the noble elegance of a sable antelope popped into my head. Incidentally, during the Mayor's last bid for re-election his political opponent, the mudslinging boar Lucius Druggs, tried to build support with the campaign slogan, "Mayor Neighs? This town deserves better than a condiment!" Neighs responded with, "Just Say Neigh to Druggs," and won in a landslide.

# DAY 563 ▶

## Italian Bull Mastiff

This panting pup was drawn with a ballpoint pen. Over the course of a couple of hours I steadily picked away at it, slowly building up the shadows and filling out his fleshy details. With time, energy, and focus all aligned, drawing becomes a form of meditation that can be very relaxing.

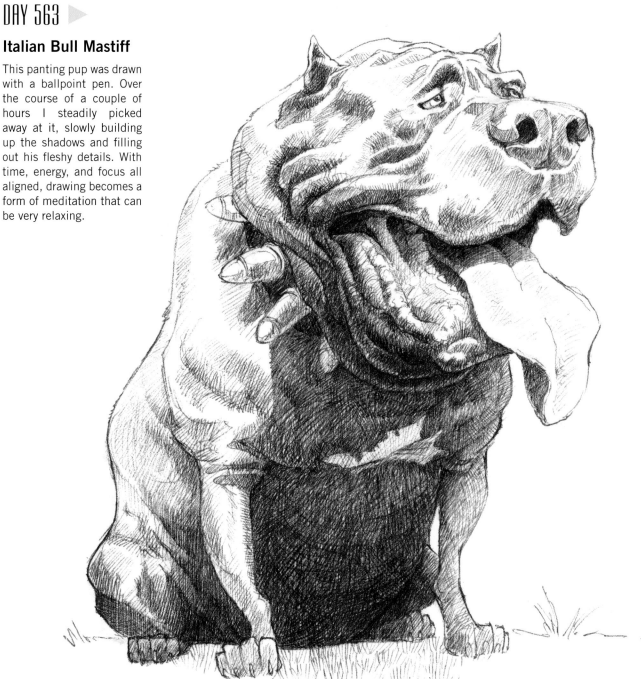

# DAY 564 ▷

## Koala

As a belated birthday gift, Thasja surprised me with a sleepover at the San Diego Zoo. The next morning we were treated to a Q & A with one of the koala keepers. Liking their sleep, koalas are often curled up in the crook of a tree, so you can imagine my delight when one peered over at me from his eucalyptus perch. The photo I snapped at that moment was used as reference for this drawing.

# DAY 565 ▷

## Pudlin

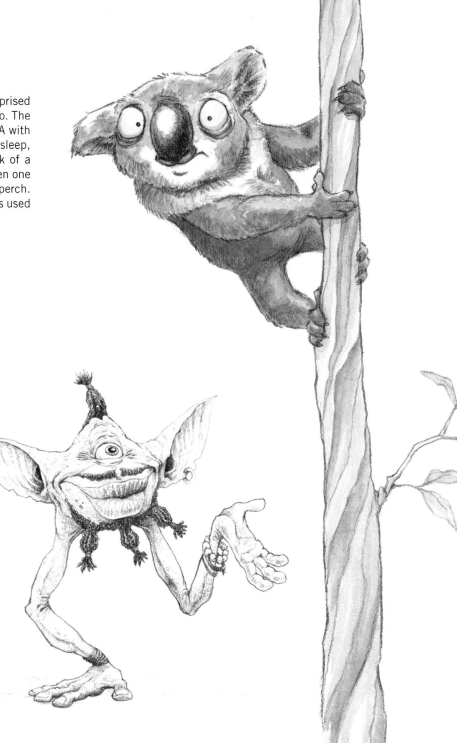

I just started moving the pencil around and simultaneously concocted this creature and his back story. Pudlins are imp-like creatures, about the size of rabbits, which once existed in the Caribbean and were thought to bring good fortune to those who encountered them. Early sea merchants trapped and kept them aboard their vessels to ensure speedy passage and protection from pirates and bad weather. Unbeknownst to the sailors, the pudlins' "luck" was really just a natural release of cross-species pheromones which chemically triggered an increase in human endorphins. This made the sailors feel good, but had nothing to do with luck. Unfortunately, pudlins lost their "potency" when captured and forced to "luckify" a single master and quickly became drained and withered, eventually dying. Though rumors persist that they still exist, there have been no confirmed pudlin sightings for over 150 years.

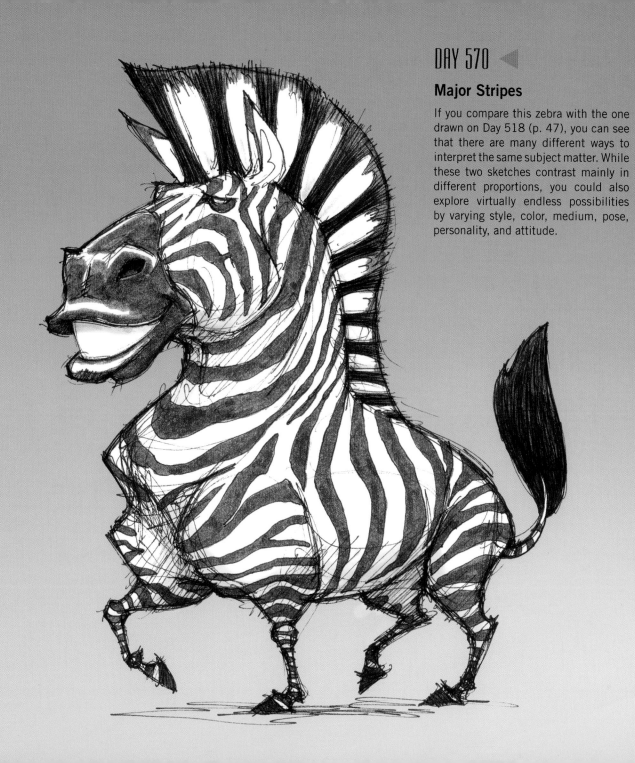

## DAY 570 ◄

### Major Stripes

If you compare this zebra with the one drawn on Day 518 (p. 47), you can see that there are many different ways to interpret the same subject matter. While these two sketches contrast mainly in different proportions, you could also explore virtually endless possibilities by varying style, color, medium, pose, personality, and attitude.

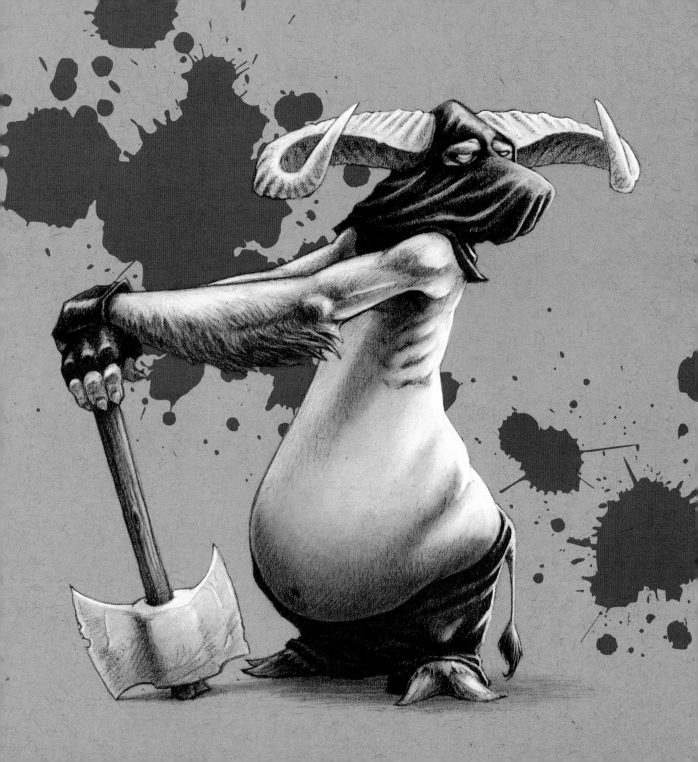

## DAY 576 ▼

### Bald Eagle

When my chemo treatments left *me* bald,
I wish I had looked as regal as this eagle.

## DAY 574 ◀

### Death and Axes

When facing any serious illness, it's only natural to think a little—or most likely *a lot*—about your own mortality. It changes from an abstract topic to a present possibility that seems all too real and tangible. It's scary. I hope my name doesn't show up on the Grim Reaper's Collection List for a long, long time, but it's not something that I concern myself with too much. I'm too busy living.

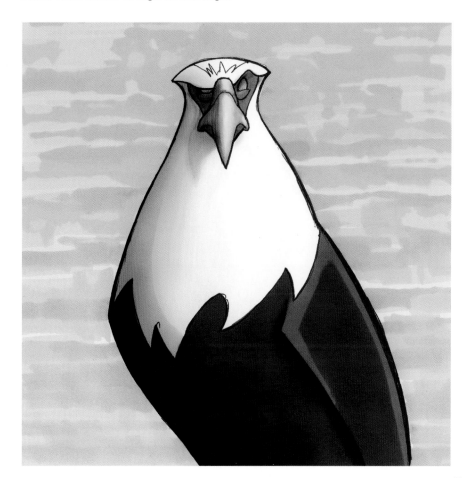

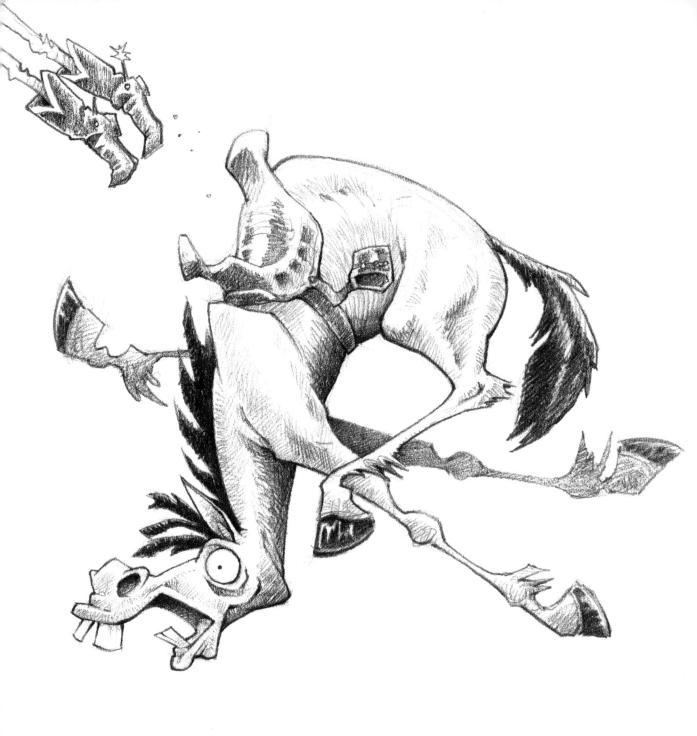

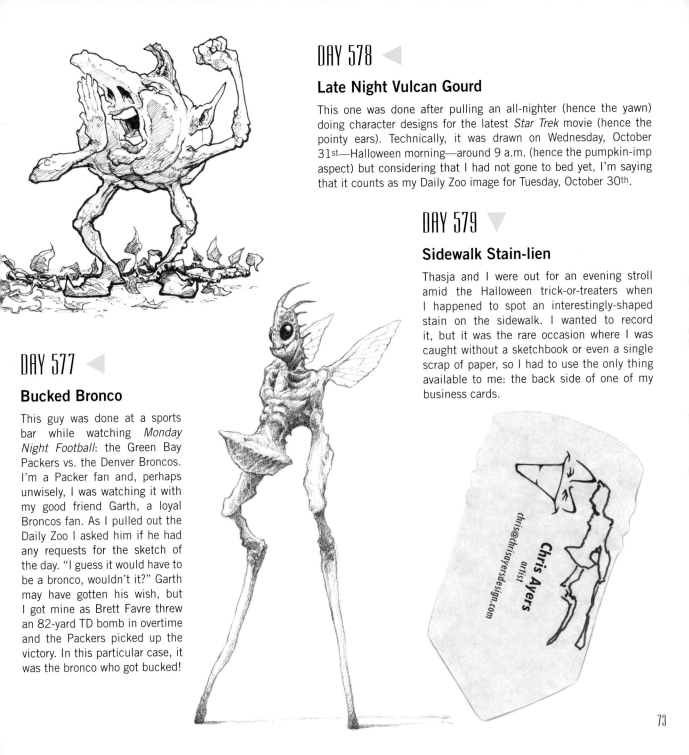

## DAY 578 ◀

### Late Night Vulcan Gourd

This one was done after pulling an all-nighter (hence the yawn) doing character designs for the latest *Star Trek* movie (hence the pointy ears). Technically, it was drawn on Wednesday, October 31st—Halloween morning—around 9 a.m. (hence the pumpkin-imp aspect) but considering that I had not gone to bed yet, I'm saying that it counts as my Daily Zoo image for Tuesday, October 30th.

## DAY 579 ▼

### Sidewalk Stain-lien

Thasja and I were out for an evening stroll amid the Halloween trick-or-treaters when I happened to spot an interestingly-shaped stain on the sidewalk. I wanted to record it, but it was the rare occasion where I was caught without a sketchbook or even a single scrap of paper, so I had to use the only thing available to me: the back side of one of my business cards.

## DAY 577 ◀

### Bucked Bronco

This guy was done at a sports bar while watching *Monday Night Football*: the Green Bay Packers vs. the Denver Broncos. I'm a Packer fan and, perhaps unwisely, I was watching it with my good friend Garth, a loyal Broncos fan. As I pulled out the Daily Zoo I asked him if he had any requests for the sketch of the day. "I guess it would have to be a bronco, wouldn't it?" Garth may have gotten his wish, but I got mine as Brett Favre threw an 82-yard TD bomb in overtime and the Packers picked up the victory. In this particular case, it was the bronco who got bucked!

Chris Ayers
*artist*
chris@chrisayersdesign.com

73

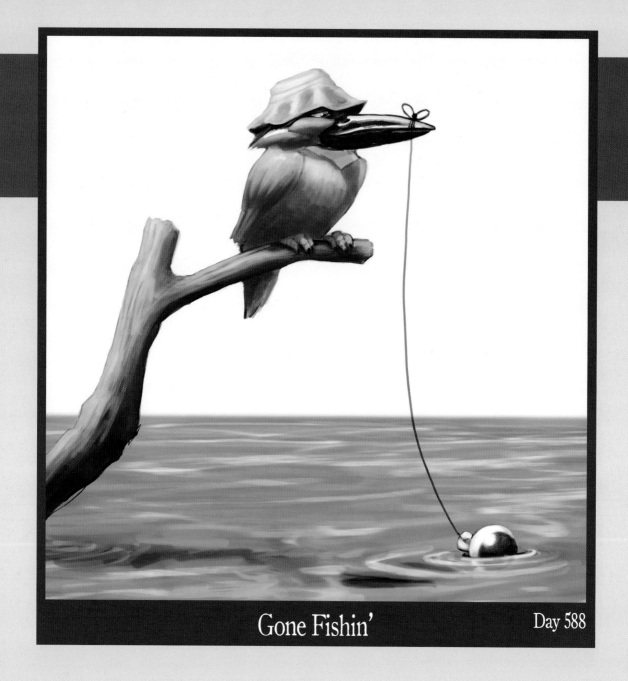

Gone Fishin'                                          Day 588

# november 07

Pardon the pun, but I have yet to be hooked on fishing. It requires a lot of patience. I do consider myself a fairly patient person, however, as being an artist also demands a great deal of patience. There are skills to learn, techniques to master, and experiments to try (which often fail the first time). It can be a slow and frustrating process. I've never thought about throwing in the towel completely with art, but there have been times when the frustration of desired results eluding me time and again made me want to walk away for a while. Then, after a short break, I can take another crack at the problem with renewed energy and focus. Most art takes time—and there's no shortcut—you simply have to put in that time.

Being a patient patient was of immense help to me while I was battling cancer. The acute myelogenous leukemia developed very quickly—only a few weeks passed between the initial onset of symptoms and my diagnosis—but it took a *long* time to get rid of it. Healing can't be rushed. Certainly, there are things one can do to make it perhaps go more quickly or smoothly: getting rest, not overextending oneself, eating well, etc. Unfortunately though, there was no magic wand to wave, no "Abracadabra" to shout, to make my cancer vanish. At one point I had self-administered morphine to help me deal with the painful side effects of treatment and I recall watching the second hand move in slow motion around the face of the clock, waiting miserably for another eight minutes to pass so I could again push the "happy button." Once I completed treatment, my body took a long time to fully recover and there was nothing for me to do but take the journey bit by bit.

Patience is an invaluable trait, not just in art or dealing with illness, but in life. As our world gets more and more accustomed to instant gratification—email, cell phones, instant information via the Internet...—how will we best cope when we find ourselves in a situation where there is no quick fix?

## DAY 580 ▶

### Afghan

So...much...hair!

## DAY 585 ▼

### Badger Flamenco?

This badger was drawn rather quickly because I had noticed that many of the recent Daily Zoo images had been more detailed and rendered and I felt the urge for a looser approach. I quickly laid down a few lines for his torso and feet and I liked the flow of the pose but wasn't sure what that translated into him doing with the upper part of his body. It was then that I was reminded of some flamenco dancers and—*violà!* I decided to leave out the castanets and flowing ruffled dress, however.

## DAY 582 ▶▶

### Ssssam Sssspade

I wrote the following moments after completing this snake: "Exhilaration. That's what I'm feeling right now. Not complete, exuberant, fantastical exhilaration mind you, but *pretty good exhilaration*. I like today's Daily Zoo. It's fun. I wanted to draw an animal with more specific character rather than just a study in form. But the exhilaration aspect comes mainly from the fact that about an hour ago this guy didn't EXIST. He wasn't even in my head—not consciously at least. I wasn't sure what to draw, and honestly I can't remember the thought process that resulted in a film-noir, serpentine pulp detective waiting under a street lamp. It all happened rather quickly. I feel very fortunate to experience that 'birth' and to experience it on a fairly frequent—well, daily—basis. The process doesn't always result in the same level of satisfaction, but each day it is like excitedly opening a present on Christmas morning. Yes, sometimes it's a three-pack of briefs from Aunt Petunia, but more often it's something unexpected and tasty: another introduction to a feathered, finned, or furry friend."

# DAY 589 ▼

## Light on Her Feet

At the time of this drawing I was designing some fairies for a freelance project, so for the day's sketch I tried to think of what would make the most *unfairy*-like fairy. How about a big, slow-moving, heavy elephant? While I was in the hospital undergoing treatment, I certainly wouldn't have minded a visit from a fairy godmother...or even a fairy god-elephant. Aside from a quick fix to my whole leukemia situation, I probably would have wished for better daytime TV choices and an energy protein drink that actually tasted good. Oh, and, of course, world peace.

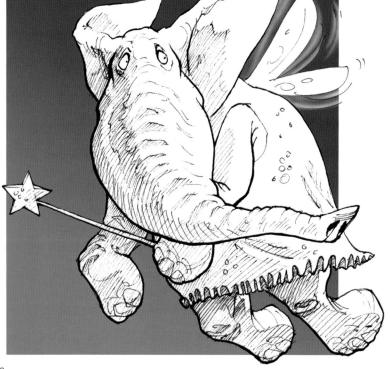

# DAY 592 ▲

## Pachyderm Plummet

What's the story here? Is this elephant falling or did he jump? Is he cannonballing into the local watering hole? Or perhaps he was dropped by a super-sized eagle? Shot out of a circus cannon? Bouncing on a trampoline? Maybe just chillin' in an invisible hammock? If he's falling, where is he falling from? How far is the drop? What's below? Thorn bushes? A pool of hungry crocodiles? A mound of pillows or a pile of freshly-raked leaves? A giant tub of Jell-O? What would you want to fall into to?

## Thinking Big

Don't we all have moments where we wish we were just a little bit bigger? Wouldn't it be great to be able to reach the jar on the top shelf without using a stepstool? Or not be chosen last for the pickup basketball game? Or get noticed for that long overdue promotion? Or simply choose to take the high road in a challenging situation? If only it were as easy as learning to walk on stilts.

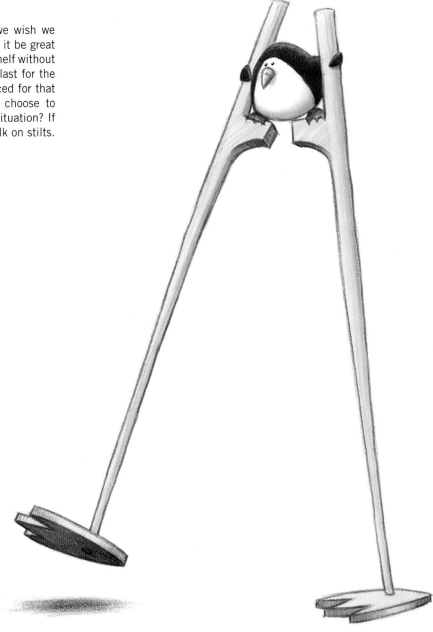

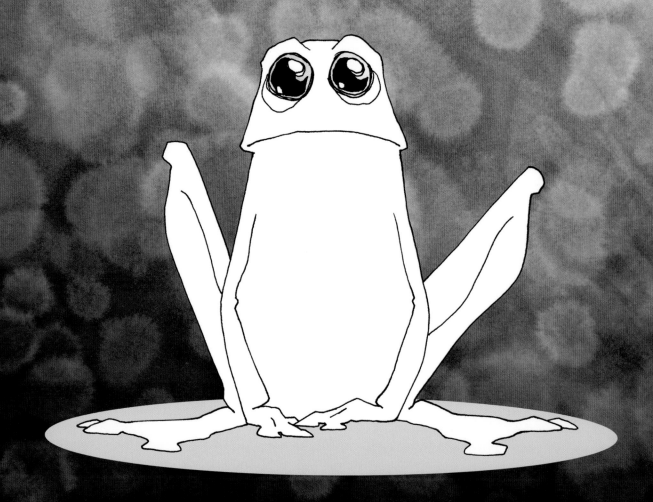

While visiting Rhode Island for Thanksgiving, I spotted a white cylindrical shape with a couple of prominent dark circles on a billboard along the freeway. I can't remember exactly what it was—a hair dryer? A humidifier? An air conditioning unit? I'm sure the company who spent big bucks to develop a foolproof advertising campaign for their product would be dismayed to hear that it didn't leave more of an impression—or at least the type of impression they were hoping for. I think it was some type of slick industrial product or consumer electronic; definitely *not* a frog.

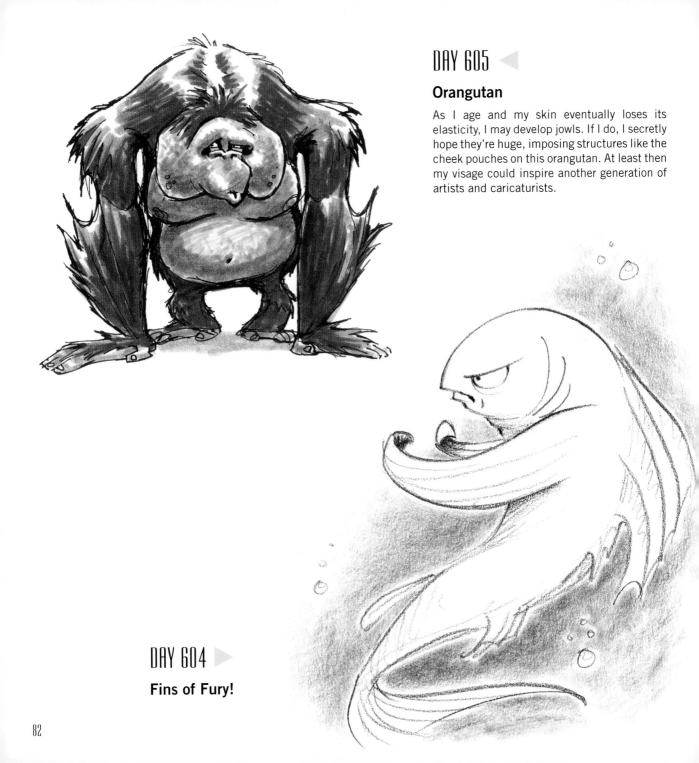

## DAY 605 ◄

### Orangutan

As I age and my skin eventually loses its elasticity, I may develop jowls. If I do, I secretly hope they're huge, imposing structures like the cheek pouches on this orangutan. At least then my visage could inspire another generation of artists and caricaturists.

## DAY 604 ►

**Fins of Fury!**

## Slab of Porcupine

For beginning artists, and sometimes even for the pros, it can be overwhelming to draw an animal right off the bat, but it becomes much easier if you break it down into simpler shapes. Most everything is made up of a combination of ellipses, quadrilaterals, and triangles. In 3D that translates to spheroids, rectangular solids, cylinders, pyramids, and cones. By arranging these simple shapes in different combinations, adjusting their sizes and proportions, you can build a character's overall anatomy as well as details such as ears, eyes, noses, and fingers. After you establish this building block skeleton, you can flesh out the details and blend the forms into one another for a more organic appearance.

Sometimes however, as in the case of this porcupine, I like to stick with very simple, graphic shapes for a character's final form. He is basically a subtly-arched slab with a couple of bent cylinders for legs and his face consists of very simple shapes. It all depends on the tone and style you want for the character. This guy reminds me of cross between Gumby and a Koosh ball.

### Tamandua Emperor

Inspired by my lunch break reading—an article about the Mayan civilization in *National Geographic*—I pulled out the Daily Zoo sketchbook and proceeded to draw a tamandua emperor. Tamanduas are small, fuzzy anteaters and I gave this one a tall headdress to overcompensate for what I imagined might be a bit of a Napoleon complex. Because these arboreal creatures are inherently cute, I added a fierce jaguar motif to his headdress to perhaps help elicit more respect from his subjects.

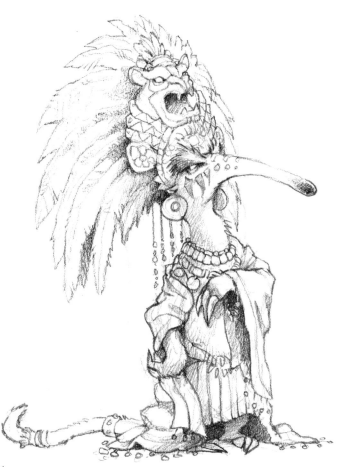

### My Cave

On Day 609 this is how I felt. I was coming down with a cold, feeling fatigued, my nose was running, and my head was slowly being squeezed by an invisible but all too real vise. Plus it was a cold and rainy day (yes, we get those in Los Angeles on occasion). My congested head made me feel thick, clumsy, and plodding—like a bear. I just wanted to crawl into my cave and hibernate for a while.

No one enjoys getting sick, but it can be especially troubling for someone who has survived cancer. A little case of the sniffles can bring the ominous specter of: "The Cancer Is Back!" The first time I got significantly sick post-leukemia was in early June 2006, almost a year after most of my treatments had ended. I developed symptoms that were eerily similar to those I had had in the days leading up to my original diagnosis. Initially I was able to remain calm, but after several days my thoughts went to a very dark place and I thought the cancer was back. I tried to prepare myself for what I believed was the inevitable news that I had relapsed, which my oncologist had once told me would be a "very bad thing." Most often I border on being annoyingly optimistic, but at this moment I was convinced my expiration date was near at hand.

After giving the symptoms another day or two to clear, which they stubbornly refused to do, I informed my doctor of the situation and asked when we should call in the cavalry. I was in his exam room the following afternoon for blood work and a checkup. Luckily, the cancer had not returned and my body was just dealing with a minor bacterial infection. *Whew!* I think my concern was a normal reaction and I've gotten sick several times since then. Each time I do my best not to jump to conclusions and I've found that it has gotten easier the longer I've been in remission. My oncologist, Dr. Gary Schiller, wisely reminded me during that checkup that, as a cancer survivor, I was "allowed to get sick once in a while just like everyone else."

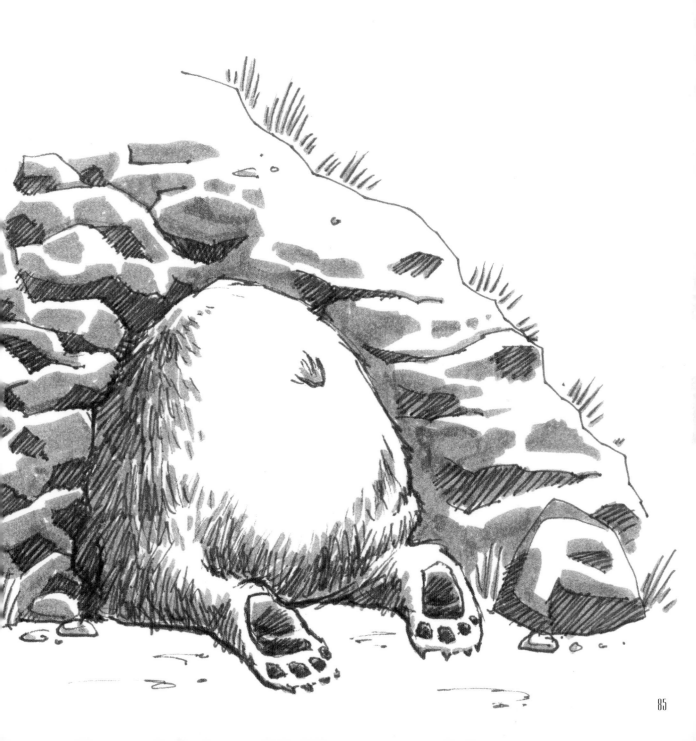

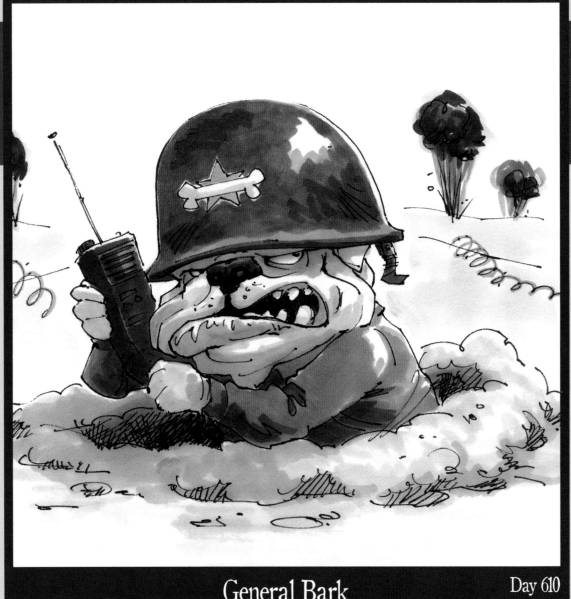

General Bark

Day 610

# december 07

To be blunt, cancer is hell. It is a nasty, dirty war between you and an army of hostile microscopic demons. As I mentioned earlier, you can choose either to fight or to give up. Odd as it may sound, part of my fight included surrender, which I view differently from giving up. Many things in a duel with cancer, and with life in general, are out of your control. When you accept this, there is a moment of surrender, of letting go, which can bring peace and comfort—a sense of freedom blossoms. The weight on your shoulders lightens. The tension and fear lessens. Then you can focus your energy on the things which you *can* control.

During my hospital stays I did my best to fight the cancer. I took my medications. I rested. I followed the instructions of the doctors and nurses. I educated myself about leukemia. I reluctantly gulped down the flavor-challenged protein drinks. I meditated and did positive visualization. I tried to remain optimistic. At some point, though, I felt there was no more I could do and the rest was out of my hands. With that realization came great peace and calm. I'm a gentle person by nature, but I was drafted into a war with a terrible foe and I discovered courage and strength which I didn't know I possessed. It was an eye-opening thing to learn about myself but a painful and torturous way to learn it.

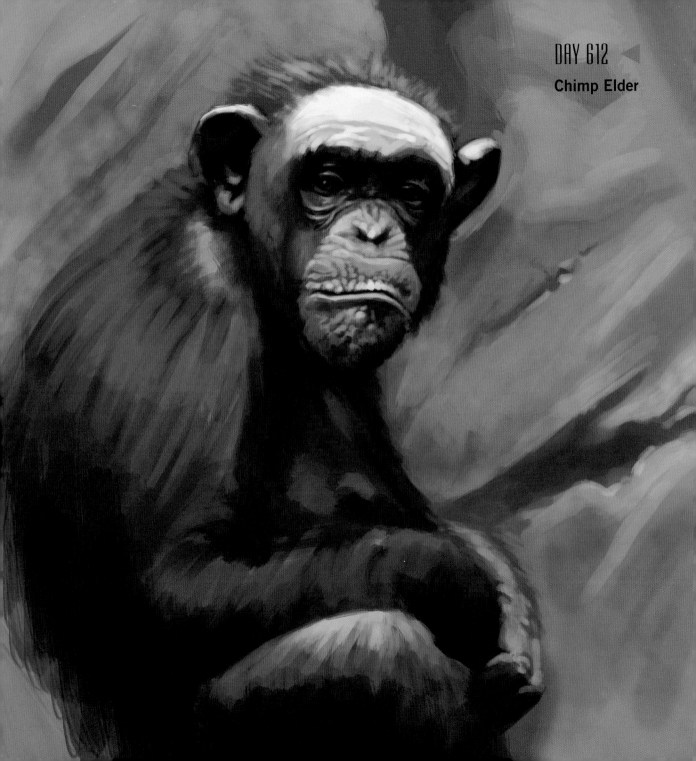

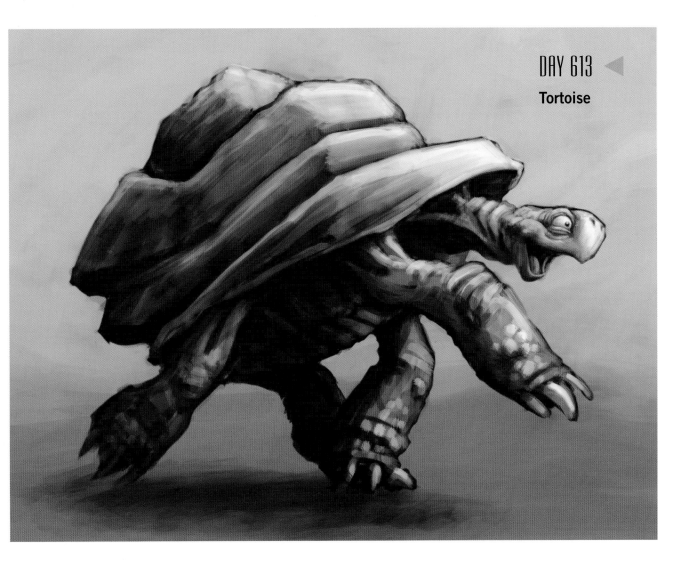

I like the juxtaposition of these two images. Both depict elderly animals, but where the chimp appears weary, the tortoise still has a lot of spring in his step. The grizzled chimp is also rendered in a more realistic style, while the truckin' tortoise is a bit more cartoony. This made me wonder if it is easier to stay youthful if we are able to keep things light, maintain a sense of humor, and essentially remain "cartoony."

Cartoon characters are often elastic beyond the rules of physics and invulnerable to things such as dynamite, plummeting ACME safes, and falls from great heights (just ask Wile E. Coyote). Perhaps one of the keys to staying young at heart is to imagine that we're made of rubber when we take those metaphorical falls in life or run head first into the side of a mountain that has been deceptively painted to look like a tunnel. If we keep this mindset, maybe we can bounce back a little more quickly and keep on chasing those pesky roadrunners.

# DAY 627 ▶

## Out of Control

I'm a big fan of the band U2, and I drew this lizard while listening to their song "Out of Control." I imagined a character struggling in a world where things were spiraling out of control and him being frustrated that he was helpless to do anything about it. Perhaps extreme chaos isn't the best thing to associate with an engagement and marriage, but Thasja and I used the sketch for our save-the-date cards in preparation for our wedding at the Minnesota Zoo. We like being a little unorthodox.

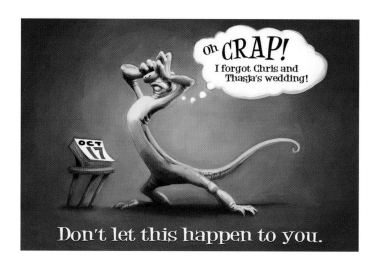

Oh **CRAP!**
I forgot Chris and Thasja's wedding!

**Don't let this happen to you.**

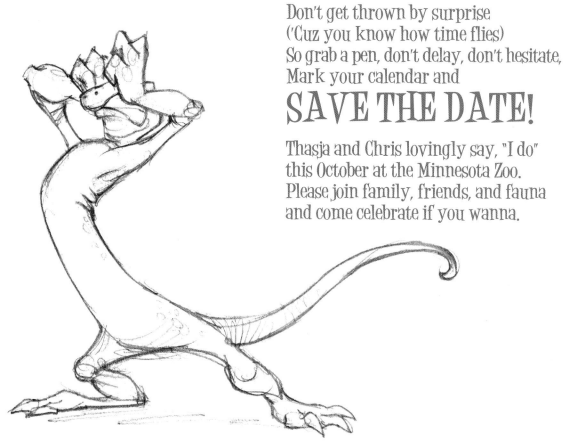

Don't get thrown by surprise
('Cuz you know how time flies)
So grab a pen, don't delay, don't hesitate,
Mark your calendar and

# SAVE THE DATE!

Thasja and Chris lovingly say, "I do"
this October at the Minnesota Zoo.
Please join family, friends, and fauna
and come celebrate if you wanna.

DAY 629 ►

## Sticky Predicament

Los Angeles is home to the famous La Brea Tar Pits, pockets of asphalt that have been bubbling and oozing to the surface for tens of thousands of years. Numerous fossils have been found in the pits, including those of mammoths, saber-toothed cats, dire wolves, ground sloths and other inhabitants from the last Ice Age.

Most of us can relate to the feeling of being trapped and pulled under by the busyness of life at times. It can be a real challenge to keep our heads above the surface. I try my best to keep my priorities in order and shed the extraneous stuff. That way, I can hopefully keep afloat and avoid becoming a fossil myself anytime soon.

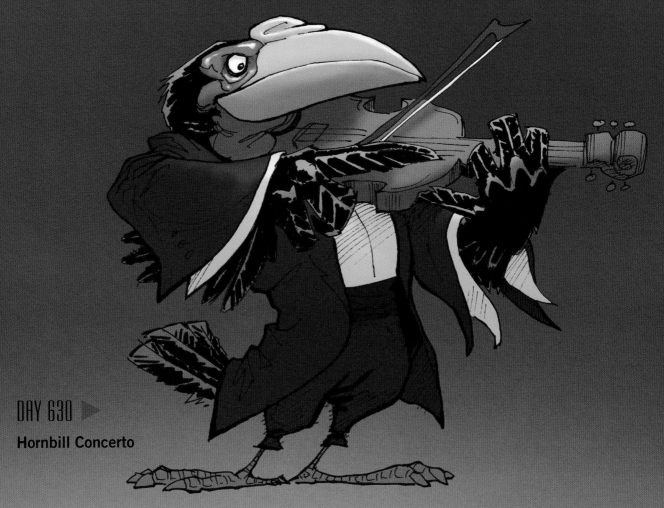

## DAY 630 ▶

## Hornbill Concerto

Music can be magical. While home for the holidays I attended a performance of the St. Paul Chamber Orchestra with my dad. We were fortunate enough to get there early and grab front row seats. It was a beautiful and moving experience—and not just the sound. The physicality of the musicians' performances was fascinating. The dexterity and agility required to not only play an instrument, but to coordinate those movements with others to create music was truly impressive and—combined with the sounds they were creating—magical, otherworldly, and almost incomprehensible. I'm making it sound as though I had never seen musicians play live before, but seeing this

talented group of artists so close up *was* almost like seeing it for the first time. I drew the day's sketch during the short intermission and added the color later.

In addition to being magical, music can be a powerful healing agent. I'm not saying Mozart will mend measles or Chopin will shanghai shingles, but I do believe at the very least music can relax us and put our body in a better position to work alongside other forms of treatment to fight illness. I listened to music quite a bit while I was undergoing treatments and then later recovering.

## Minotaur

Any time I visit my parents back home in Minnesota I know that part of my stay will have to be devoted to going through some of my childhood belongings in the ongoing effort to help clean out the closets, basement, and garage. On this particular day I came across a book on Greek mythology, which was another of my childhood obsessions. Which kid doesn't love tales of heroes and heroines, monsters and deities—all with really difficult-to-pronounce names? One of my favorites was the myth of Theseus because it featured the Minotaur—a half-man, half-bull creature which dwelled in King Minos' labyrinth on the island of Crete.

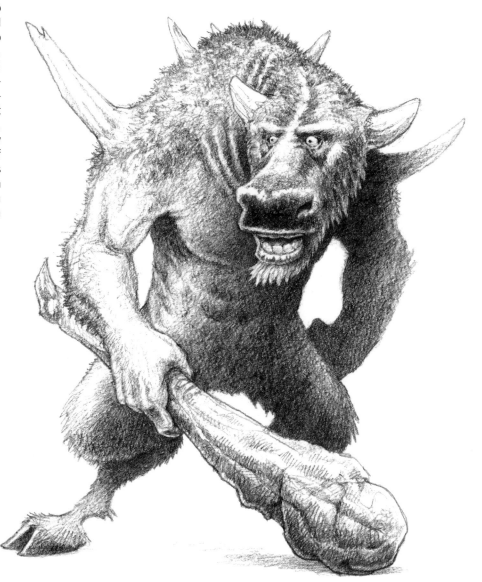

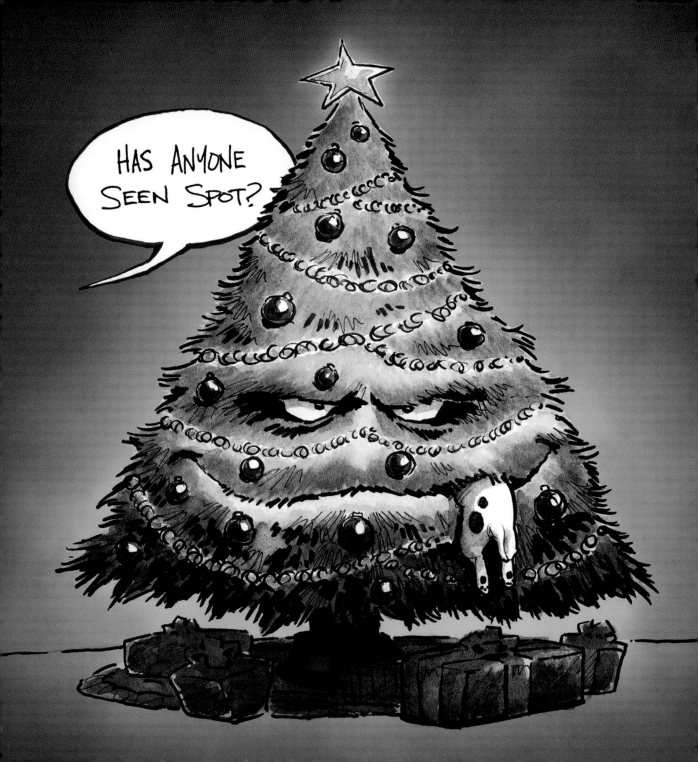

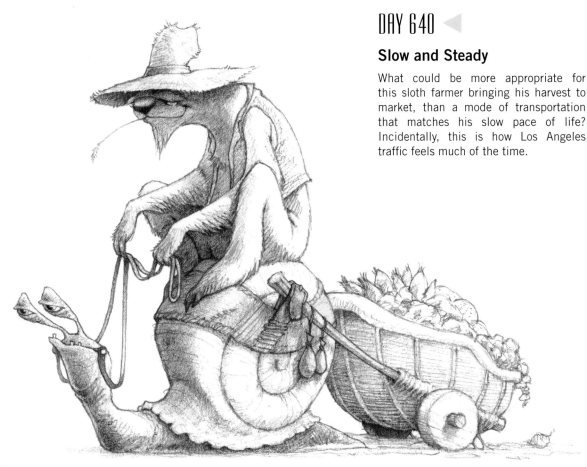

## DAY 640 ◄

### Slow and Steady

What could be more appropriate for this sloth farmer bringing his harvest to market, than a mode of transportation that matches his slow pace of life? Incidentally, this is how Los Angeles traffic feels much of the time.

## DAY 633 ◄

### Spot Remover

This menacing—or perhaps just innocently hungry—tree was drawn at Grandma's house on Christmas Eve and eventually became my holiday card for 2008. In the weeks that followed sending the cards, I received interesting feedback from some of my friends. One told me that it didn't sit too well with her three-year-old son: "Mommy, I don't *like* that tree..." Way to go, Chris—traumatizing the next generation with an irrational fear of trees!

The young boy of another friend couldn't understand why the little dog would get close enough to the tree to become a snack. This gave his father a prime opportunity to explain the concept of camouflage. After their discussion, the idea of a carnivorous Christmas tree and the unfortunate demise of a beloved family pet seemed completely logical. Perhaps a future volume of *The Daily Zoo* would be eligible for an educational grant?

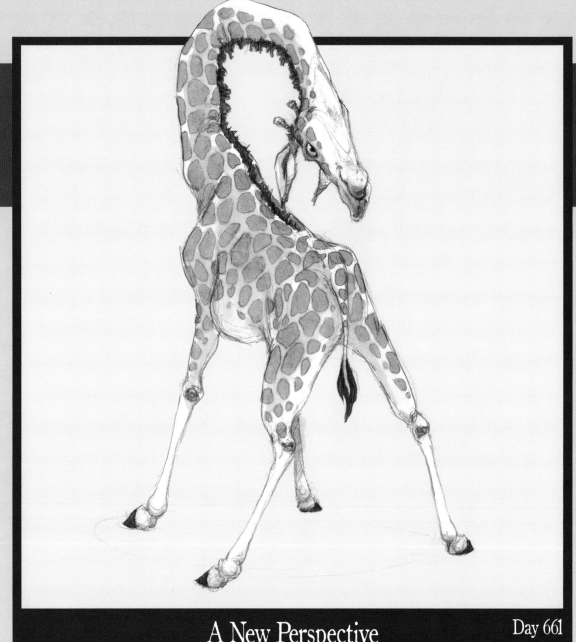

A New Perspective

Day 661

# january 08

Imagine seeing the world from eighteen feet above ground like a giraffe…or from just a mere millimeter like an ant. Your surroundings would appear significantly different and certainly offer a new perspective. Cancer gave me new perspectives. It bestowed upon me a much greater understanding of what it means to be sick and the physical, mental, emotional, and spiritual challenges that that entails. The relationship between me and cancer is constantly, though subtly, changing. After a jarring round of introductions, we started reluctantly getting to know one another. After we came to the "agreement" that It was not welcome in My body, our relationship improved. We are by no means the best of friends these days, but it is and will forever be a part of my life experience. I am still learning what it means for me to be a cancer survivor and how that affects my day-to-day decisions and perspective on life.

Sometimes you consciously seek out a new perspective and sometimes one hits you unexpectedly. While delivering a hot-off-the-press copy of *The Daily Zoo* to my former case manager at the UCLA Medical Center last fall, I had a moment to take in the view of the oncology ward hallway with its many patient room doors lined up like broad sentinels. *BAM!* It hit me just how strange it felt—what a different perspective it was—to be standing there as a healthy, strong, four-year cancer survivor instead of the weak and withered shell I had been only a short time before. How different the world looked from here, even just on the opposite side of a door. Another wave of gratitude flooded over me in that moment—something that I've grown accustomed to happening frequently since my introduction to cancer.

# DAY 641 ▲

**The Silence before the Thunder**

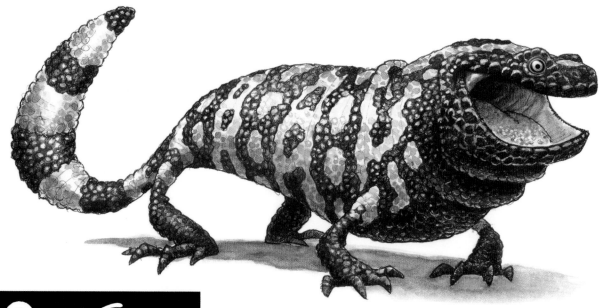

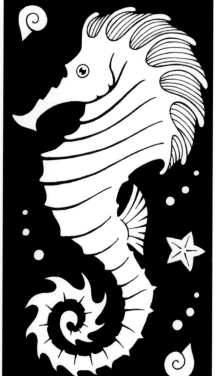

# DAY 644 ▲

## Happy Gila

The Gila monster is one of only two lizards in the world known to have a venomous bite (the other being the Mexican beaded lizard). But, come on, does this guy really look like he would bite anyone?

# DAY 645 ◄

## Seahorse

One of the peripheral benefits of scouring so much animal reference material for The Daily Zoo is that I come across a lot of interesting facts. Seahorses are the only known animal species in which the males become pregnant. The female deposits her eggs in the male's pouch, where they are fertilized and later hatch. I also learned that seahorses do not have teeth or stomachs and thus swallow their food whole and must eat almost constantly because it passes through their digestive systems so quickly. Who knew?

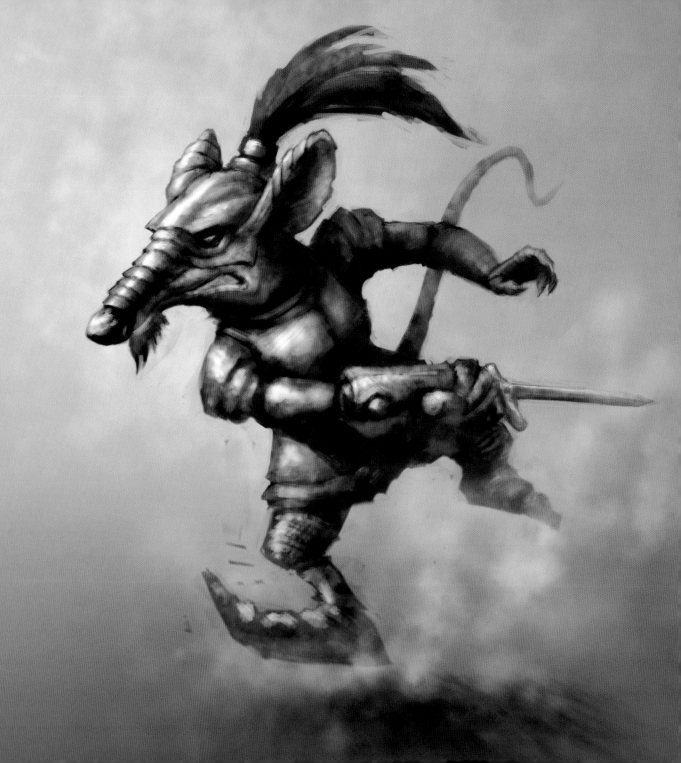

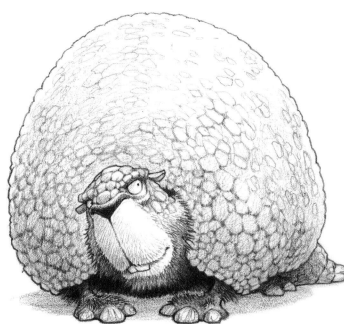

## DAY 662 ◄

### Glyptodont

Glyptodonts, prehistoric ancestors of today's armadillos, roamed the Americas during the Pleistocene era and were as large and as heavy as a small car. Fascinated by museum fossils as a child, I desperately wished for a time machine to be able to go back and see creatures such as this in the flesh.

## DAY 657 ◄

### Sir Ratcliffe (in Pursuit of Justice)

Here is Sir Ratcliffe, rushing off to vanquish the forces of evil and perform other chivalrous deeds of derring-do. Usually I feel most comfortable starting a painting with a pencil sketch, but in this instance it was done completely within the digital realm. I had intended it to be a quick study, but it sucked me in and before I knew it, it was 4 a.m.

## DAY 664 ►

### Sir Douglas (in Pursuit of the 8:15)

Unlike Sir Ratcliffe, Sir Douglas is simply rushing off to catch the 8:15 train for his morning commute to Trafalgar Square.

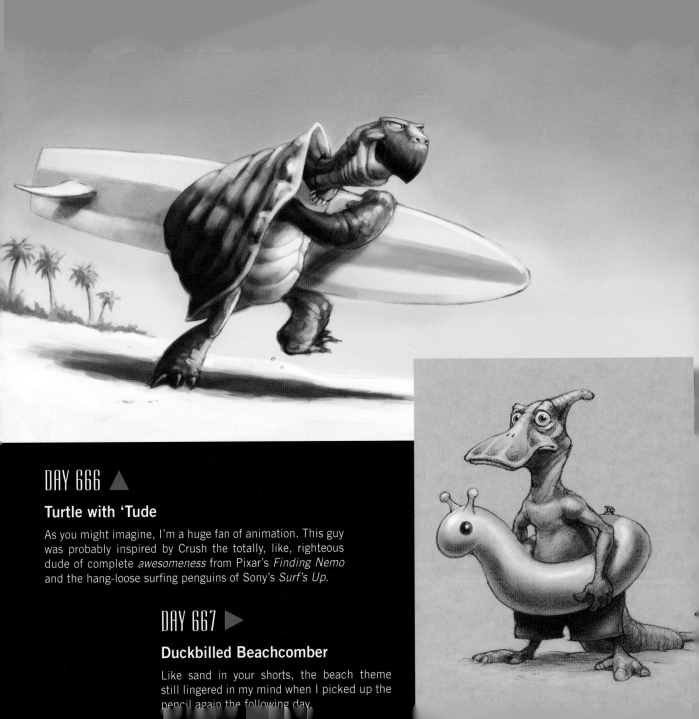

## DAY 666 ▲

### Turtle with 'Tude

As you might imagine, I'm a huge fan of animation. This guy was probably inspired by Crush the totally, like, righteous dude of complete *awesomeness* from Pixar's *Finding Nemo* and the hang-loose surfing penguins of Sony's *Surf's Up*.

## DAY 667 ▶

### Duckbilled Beachcomber

Like sand in your shorts, the beach theme still lingered in my mind when I picked up the pencil again the following day.

## DAY 670 ▶

### Dung Beetle Don

Dung beetles are an important part of nature's janitorial crew. They scour varied environments on all continents except Antarctica, collecting the droppings of other animals. Many species roll the dung into balls that can be up to fifty times their weight. From these pungent spheres they extract all the nutrients and water they need to survive and raise a brood of their own. So kids, the next time Brussels sprouts appear on your plate, remember that those round objects could be made of something much less savory.

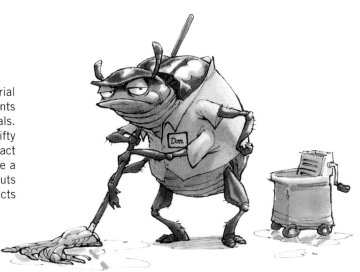

## DAY 671 ◀

### Buggin' J.J.

Around this time I was fever-ishly preparing to go to press with the first *Daily Zoo*. I had asked film director and master storyteller J.J. Abrams if he would consider writing a foreword for the book. He graciously agreed which just about made me wet my pants with excitement. I put together a package of materials so he could get a sense of the project and zipped over to the post office on my lunch break. Wanting to add a little extra touch, I drew that day's sketch right on the envelope in the parking lot and snapped a quick photo before sending it on its way.

Day 671
1/31/08

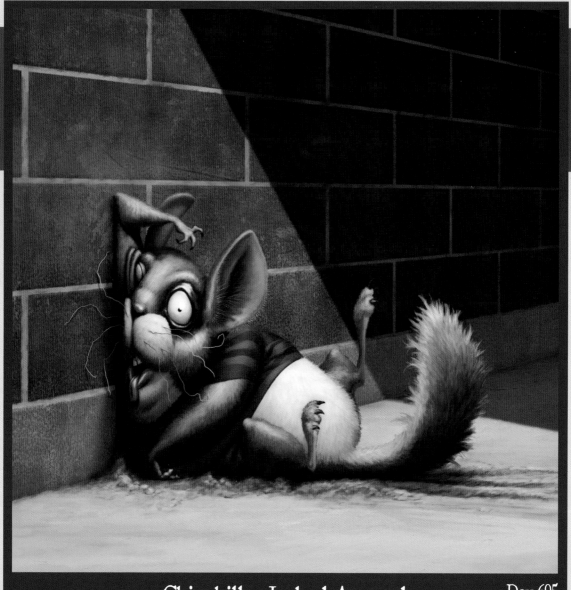

Chinchilla, Jacked Around

Day 695

# february 08

In the first *Daily Zoo* I discussed how important humor is to the healing process. The old saying, "Laughter is the best medicine," has withstood the test of time because it is so true. Fun and games with family and friends, laughing and keeping things light is potent stuff—and not just for the sick. Humor and laughter were great distractions while I was undergoing treatment. I couldn't always rely on myself to make a joke—being stuck in the same hospital room for a month at a time and dealing with a life-threatening disease isn't much of a knee slapper—so I recruited reinforcements. I read some of my favorite comics, *Calvin & Hobbes* and *The Far Side*, to provide guaranteed chuckles. Most of the daytime TV choices were not worth watching but I did look forward to reruns of *The Cosby Show* each morning, and when Thasja arrived at the hospital each night we watched episodes of *Scrubs*, which we could appreciate even more since becoming all too familiar with the nuances of hospital life.

Incidentally, the roughed up chinchilla on the opposite page originated from playing the game *Scattergories* with my visiting family. Having to start with the letter "J", my dad's entry for "reason for being late to work" was "jacked around." Fits of laughter ensued and it seemed only fitting to work it into The Daily Zoo later that night.

This was drawn on my lunch break while working at Rhythm & Hues, a visual effects and animation studio. I would soon have to cut back my hours there in order to get the first *Daily Zoo* ready for publication. It was a tough choice (good people, good work environment, good pay) but I had made a commitment to my publisher and, most importantly, to myself to see this project through. After all, one of my main post-cancer goals was to make my own art projects more of a priority.

# DAY 675 ▶

## Hunchbacked Hyena

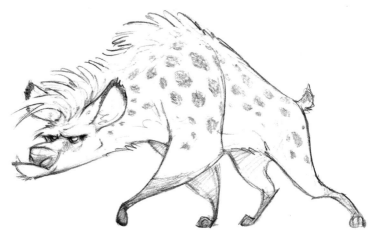

# DAY 676 ◀

## Pharoah's Guard

Jackals played a significant role in ancient Egyptian culture, perhaps the most famous example being Anubis, the god of mummification and death, who is often depicted as having the head of a jackal atop a human body. This sketch isn't Anubis, just a fierce member of the pharaoh's elite force of body guards.

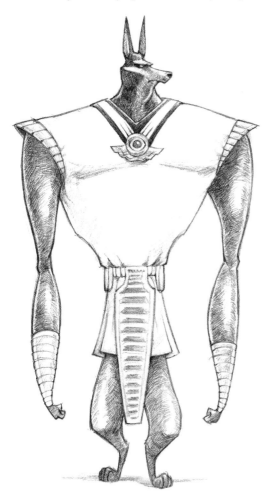

# DAY 678 ▶

## Gobblieus Rex, the Turkey King

Gobblieus Rex, or "Daddy G" as he likes to be called on Casual Fridays, was a result of dipping into the grab bag of ideation next to my desk. The small bag is filled with scraps of paper each labeled with a noun, adjective, adverb, or verb and is a good way to jumpstart the creative process when necessary. On this particular day I randomly pulled out the words "turkey," "throne," and "disgusting," the latter leading to the nearly floor-reaching wattle.

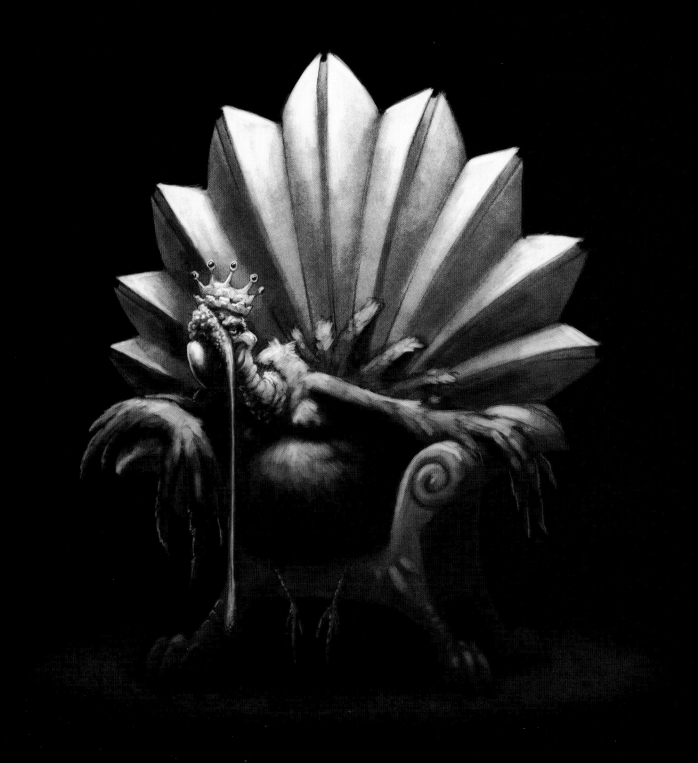

# DAY 691 ▶

## Sushi Chef

Is it still called "sushi" if it isn't fish?

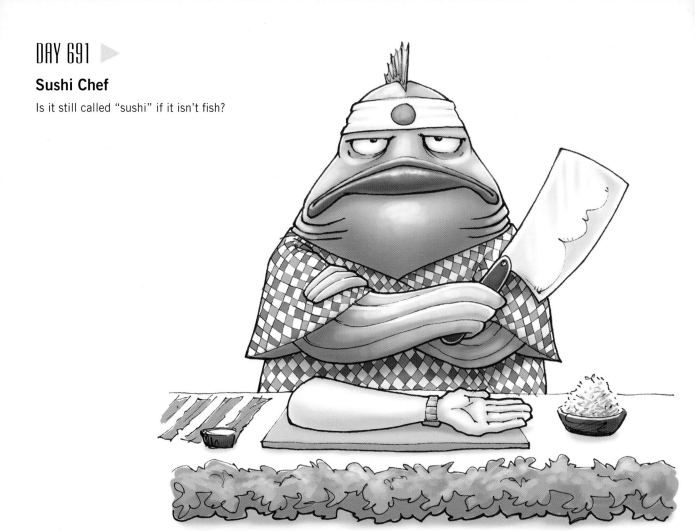

# DAY 700 ▶

## Dove of Possibility

As I mentioned earlier in this book, I'm a big fan of the band U2. Thasja and I had just returned from seeing the film *U2 3D* which, as the title implies, was one of the band's concerts shown in 3D. We saw it on the 7-story screen of an IMAX theater which made it a surreal and immersive experience. It was the closest I've come to feeling like a rock star.

Being Day 700, it was a bit of a milestone and, because I was in a particularly good mood from the inspiring music, I wanted to create an image that was more serious in tone and subject matter. So instead of a goofy frog to commemorate the day's date—February 29th, Leap Day—I drew a dove of peace...of hope...of possibility.

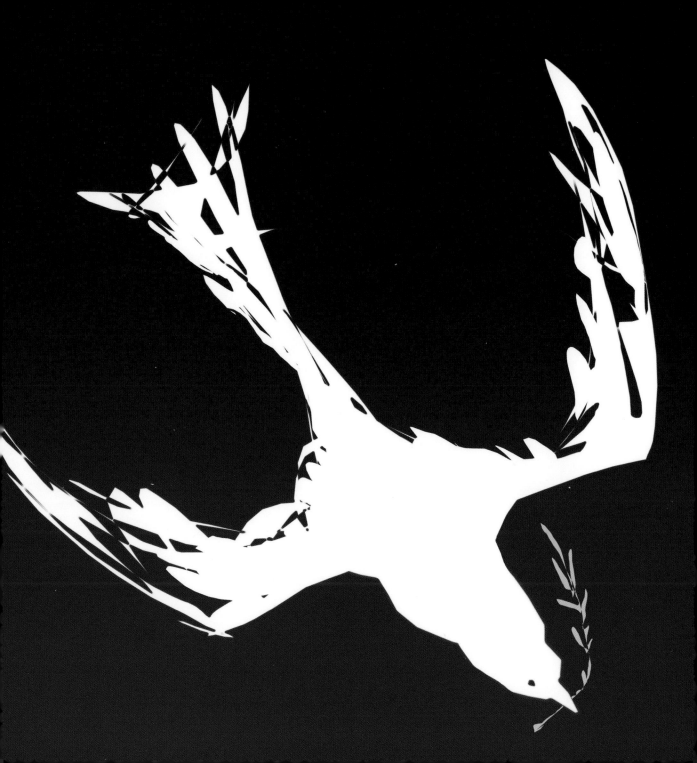

Yeehaaaaaah!

Day 708

# march 08

"Recommit!" My arms and legs were extended in mid air, starting to shake rather than just quiver. They were supported by my abdominal muscles, which were really starting to burn. "Recommit!" The yoga instructor encouraged us once again. There were about thirty seconds remaining in the pose and I refocused my attention and energy on keeping my limbs outstretched and abs strong. Soon it was over and I felt great—not just because my muscles no longer felt as if they were on fire, but mainly because the goal had been accomplished. Hearing that one simple word—recommit—was a valuable lesson and it has become a staple in my vocabulary. I have used it periodically with The Daily Zoo when the project loses some of its appeal or, more accurately, when I become too busy, tired, or enchanted by other pursuits to give it the love and attention it requires.

During any long-term project or journey—battling cancer for example—there will inevitably be obstacles, distractions, speed bumps, dead ends, and undesirable results. One must often recommit to the goal. Initially, any great challenge can seem insurmountable, which brings to mind a lyric from a U2 song that goes, "It's not a hill it's a mountain as you start out the climb." How can I draw an animal a day for an entire year? How can I become as accomplished an artist as those who inspire me? How on earth can I manage all those rounds of chemo? Daunting, yes. Impossible, no. I find solace in a quote from Leonardo da Vinci that I read years ago which went something like, "Even the tallest of towers are climbed but one step at a time." That mountain—or tower or goal or chemo regimen—may be tough and challenging, but you don't have to scale it in one day. You just have to start with that one little step. One sketch. One step toward pursuing your passion. One step toward healing.

## DAY 705 ▶

### Sad Clown

I liked the challenge of mixing an animal which is usually associated with laughter, the hyena, with an antithetical sad clown.

## DAY 704 ▼

### Scarlet Macaw

## DAY 703 ▲

### Wombat Squire

On this day I asked my wife for a suggestion. She offered "wombat." For additional brainstorm juice, I blindly put my finger in a dictionary and landed on the word "persnickety," which was defined as "fastidious, scrupulous." From there I proceeded to imagine Sir Wesley, a royal aid whose high standards and annoying attention to the smallest of details are a constant bane to the rest of the Queen's court of attendants and advisors. Who knew wombats could look so good in tights and breeches?

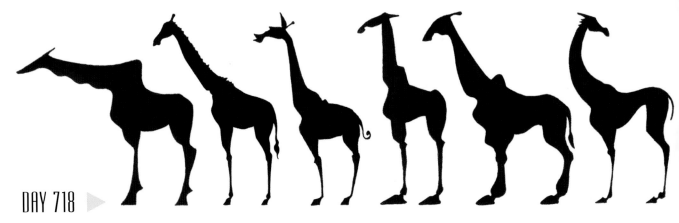

# DAY 718 ▶

## Giraffes on Parade

A good technique for quick exploration of a character is to do simple silhouette studies. This allows you to focus on the overall shapes and proportions without getting distracted by things such as facial details, wrinkles, or skin patterns.

# DAY 720 ▶

## Digital Scribble Raccoon

This raccoon has its origins in a digital "scribble pad," an approach that was introduced to me by my artist friend, Scott Robertson. In Photoshop I created some abstract custom brushes and laid down random overlaying shapes in various shades of gray (Fig. A). Next, I zoomed in and had a look around, searching for interesting shapes in both the positive and negative spaces. One of the things I saw was a raccoon which I loosely outlined (Fig. B) and used as a guide for the eventual pencil sketch. The neat thing is that I don't know if I would have come up with this particular head shape and mask pattern had I just started with pencil and paper.

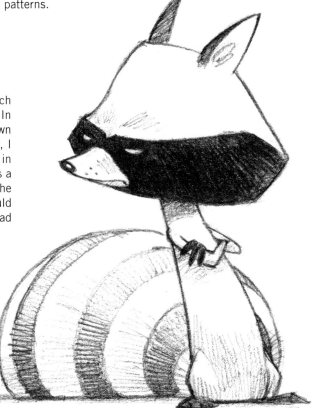

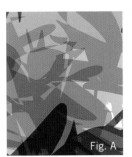

Fig. A

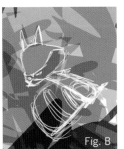

Fig. B

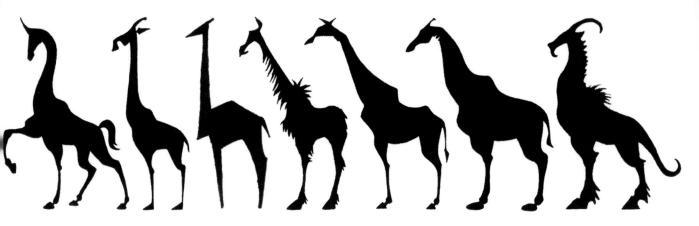

## Ambidextrous Ewes

Over time you get used to drawing certain shapes, lines, and spatial relationships and it can sometimes be difficult to break these habits and make fresh, new discoveries. On Day 721 I decided to draw with my left hand and to see what kinds of different shapes and proportions I might come up with. The bald head, the puffs of wool on her cheeks, the ultra-skinny legs, and the unnatural forward lean to her stance were a few nice surprises. On the next day I went back to using my right hand and drew the same ewe but in reverse. I'll definitely try this process again and hopefully push for even more extreme results.

I have often thought about what I would do if I somehow lost my ability to hold a pencil. Try to learn to draw with my other hand, I guess. If that were not an option, I hope I would be able to find another adequate outlet for my creative expression. But it would be heartbreaking. Battling cancer shed new light on certain areas of my life. I was always grateful for my many gifts, but after cancer that sense of appreciation has been heightened to stratospheric levels.

DAY 721
DAY 722 ▶

115

## Pachyderm Package for Patch

While preparing to go to press with *The Daily Zoo – Vol. I*, my publisher suggested getting an endorsement from a high-profile member of the medical community. When my wife mentioned Dr. Patch Adams, I instantly knew he was the perfect choice. Many people know of him only through the 1998 biographical film *Patch Adams*, starring Robin Williams in the title role. It follows Patch through medical school, where his unorthodox ways of using humor and compassion—even donning a clown nose and big shoes—as additional methods of treatment were not well received by the medical establishment. I thought he might understand and appreciate The Daily Zoo and the concept of using art and humor in a therapeutic and healing manner. There was just one problem: Patch Adams and I were complete strangers.

After finding a P.O. box on the website for The Gesundheit Institute, an innovative healthcare facility he founded, I put together a package with some sample pages of the book and a letter introducing myself and the project. Not knowing how many bags of mail he might receive each day, or if he even opens it himself, I tried to increase the chance of it getting noticed by doing the day's Daily Zoo sketch on the outside of the package. At the very least, I thought it might bring a smile to an underappreciated postal worker stuck sorting packages all day.

Despite his busy schedule of speaking engagements, clowning trips to hospitals around the world, and trying to change the way our society thinks about healthcare, Patch graciously agreed to contribute a few special words to *The Daily Zoo*, encouraging us all to bring our passions into our healing process. Thank you Patch!

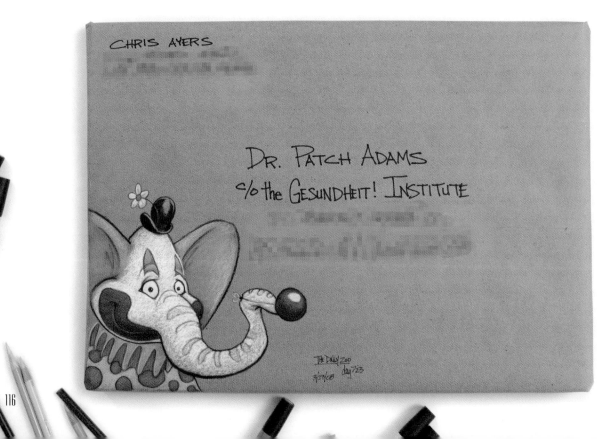

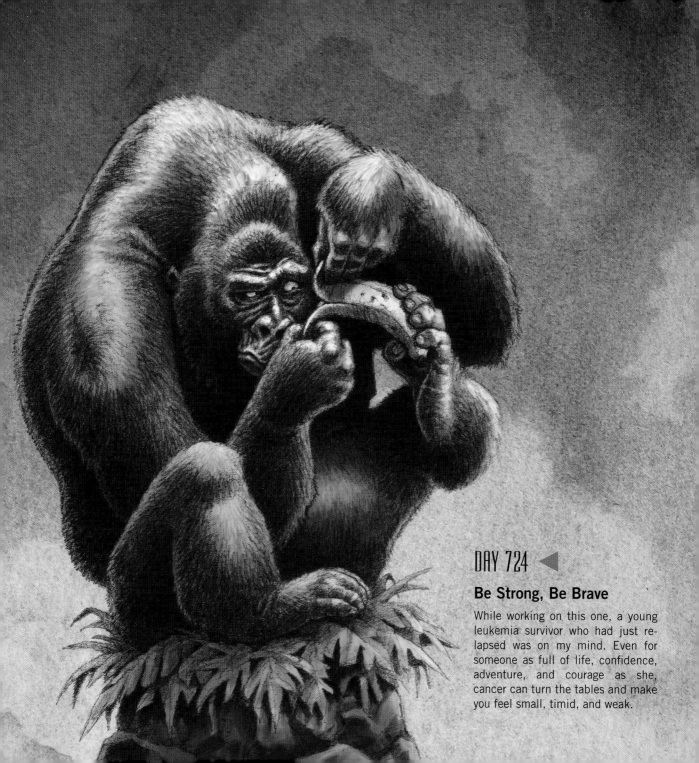

## DAY 724 ◀

### Be Strong, Be Brave

While working on this one, a young leukemia survivor who had just relapsed was on my mind. Even for someone as full of life, confidence, adventure, and courage as she, cancer can turn the tables and make you feel small, timid, and weak.

**Thirsty Frog with Eyebrows**

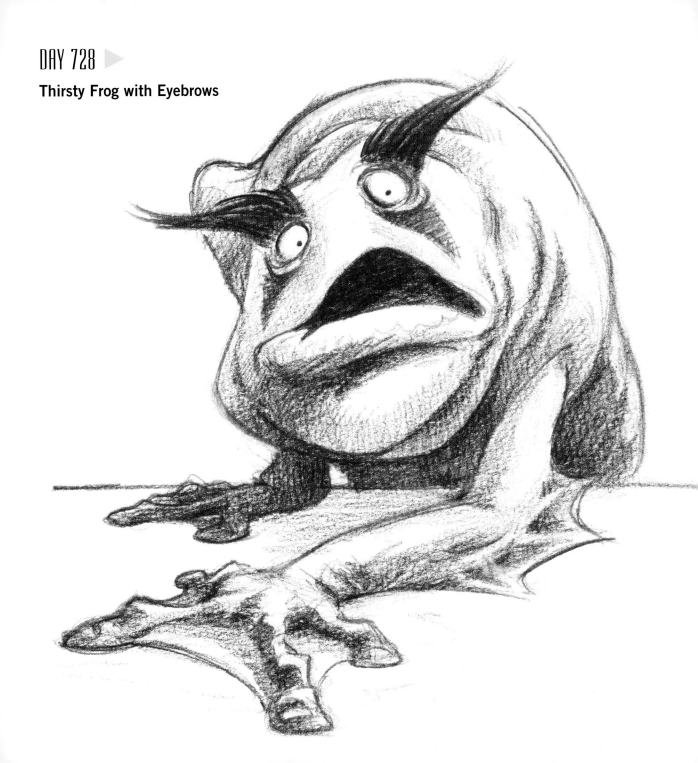

## DAY 730 ▶

**"Put...Me...*DOWN!!!*"**

## DAY 729 ◀

### Fishy Muse

Yes, fish inspire me—but so do soaring condors, slowly slithering slugs, crisp autumn breezes, and double scoops of peanut butter and chocolate ice cream. When I take the time to truly look at the world around me, not just with my eyes but also with a curious mind and open heart, I find it difficult *not* to be inspired.

# DAY 731 ▶

## Fresh Legs

Near the end of March 2008, I came tumbling and tripping toward the finish line of completing another year of The Daily Zoo. There was a bit of exhaustion but there was also the renewed energy that came with the idea of embarking on a third year; a fresh new set of legs with which my imagination could run wild.

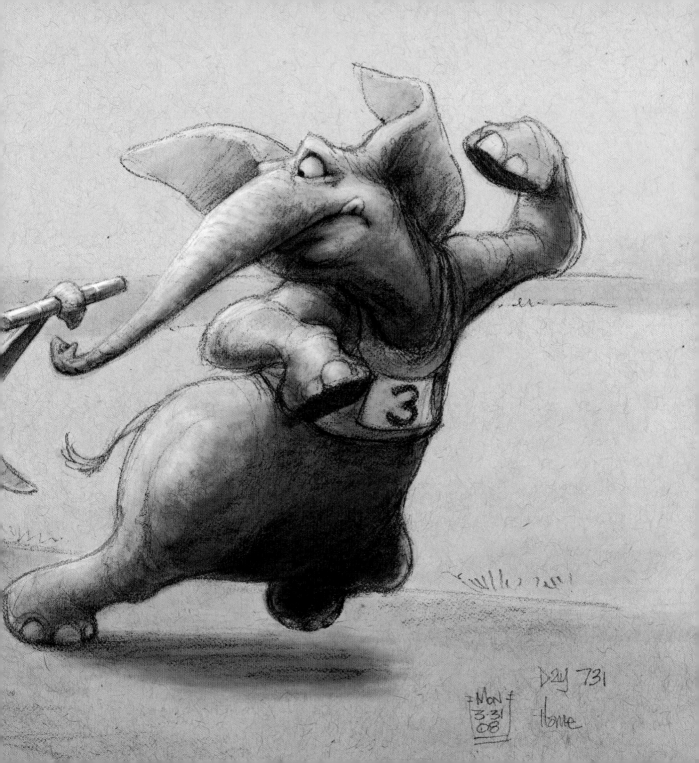

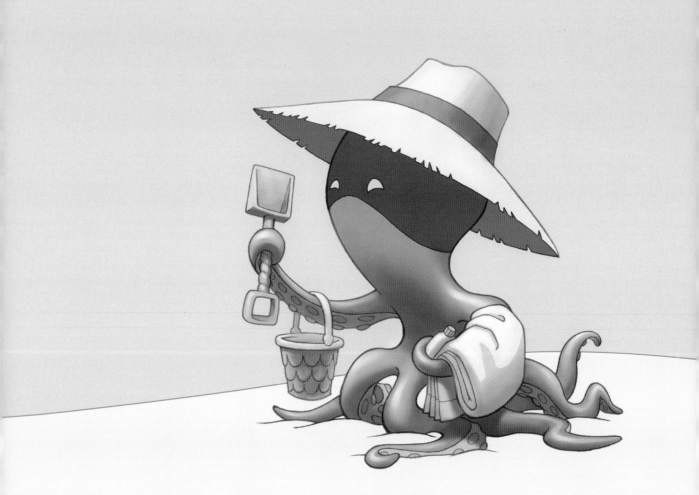

# the daily zoo

## Year Two:
## Year in Review
April 1, 2007 - March 31, 2008

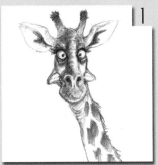

**Giraffe**    DAY 366
*What?* You mean I gotta do another year of this?
Home

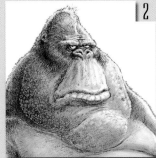

**Gorangutan**    DAY 367
A gorilla-orangutan hybrid.
Psychobabble Coffee Shop, Los Feliz

**Gila Monster**    DAY 368
Home

**Gila Monster**    DAY 369
Home

**Sperm Whale**    DAY 373
"Moby Dick"
Home

**Proud Mary**    DAY 374
By the time I was done drawing her, CCR's song was in my head, thus the title.
Home

**Walrus-Jabba Thingy**    DAY 375
Home

**Conger Bandit**    DAY 376
Inspired by a picture of a bandtooth conger eel.
Home

**Bee-eater**    DAY 380
Before eating their prey, they remove the stinger by beating it on a branch.
Home

**Highlighter Swiner**    DAY 381
Done quickly with a black Sharpie and a pink highlighter.
Home

**Penguin**    DAY 382
Priscilla the skydiving penguin from my in-progress children's book.
Starbucks, Burbank, CA

**Fishy Marm Ambassador**    DAY 383
Inspired by a picture of a yellow hamlet, a type of Caribbean fish.
Home

apr
07

**Rabbit**          DAY 370
"Peaceable Hare"
Home

**Nyala Antelope**          DAY 371
Home

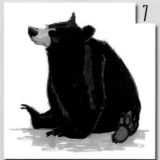

**Black Bear**          DAY 372
Home

**Nyala Antelope**          DAY 377
Nathan "Nate" Nyala was done in a
style mimicking the *Madagascar* films.
Home

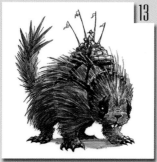

**Giant Porcupine with Rider**          DAY 378
Home

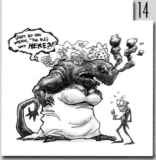

**Bridezilla**          DAY 379
Aura nightclub, Burbank, CA

**Feisty Rodent**          DAY 384
"Soon the world will be mine, all
mine!!!"
Home

**Bobcat**          DAY 385
Requested by my wife.
Home

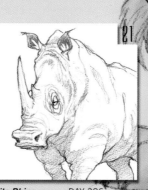

**White Rhino**          DAY 386
Home

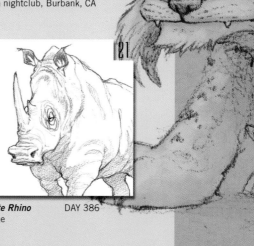

**Waterbuck** DAY 387
Home

**Hogre** DAY 388
Native to the land of Swinelandia (which is pronounced *Svinelandia*).
Home

**Hogre** DAY 389
Home

**French Poodle** DAY 390
Home

**Elephant** DAY 394
Home

**Cassowary** DAY 395
Home

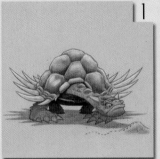

**Ankylotortoise** DAY 396
Home

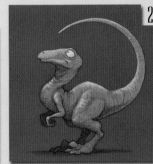

**Juvenile Velociraptor** DAY 397
Home

**Indri** DAY 401
Interstellar Iz and her sidekick, back more more in *Year Two!*
Home

**Fish** DAY 402
Home

**Unicycling Uakari** DAY 403
Home

**Visayan Warty Pig Warrior** DAY 404
Sketched while I was waiting for new tires to be put on my car.
Westside Brakes & Tire, Culver City, Ca

**26**

**Turtle**      DAY 391
"Shellshock"
Home

**27**

**Poodle**      DAY 392
"Poodle Doodle"
Amalgamated Dynamics, Inc.

**28**

**Pink Salmon**      DAY 393
Home

apr-
may
07

**3**

**Baboons**      DAY 398
"Honest! I didn't know they were your
bananas!"
Home

**4**

**Panda**      DAY 399
"Panda Ker-plop!"
Home

**5**

**Monster Head Studies**      DAY 400
Home

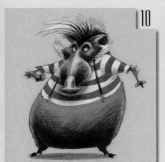

**10**

**Visayan Warty Pig**      DAY 405
Northridge Mall Food Court

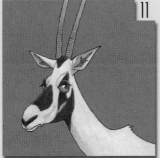

**11**

**Oryx**      DAY 406
Home

**12**

**Pigs n' Hippos**      DAY 407
"Inflatable Porcine Child Entertain-
ment Device"
The Rose Café, Venice, CA

**Furry Horned Slug**          DAY 408
His shape was inspired by an eighth-
inch swirl in the texture of the paper.
Home

**Mallard**          DAY 409
"Duck, Out of Water"
Home

**Displaced Gecko**          DAY 410
Home

**Angry Rodent**          DAY 411
"Let It Out!"
Bowyer Oncology Clinic, UCLA

**Bison**          DAY 415
I wasn't satisfied with the previous day's
bison, so had to take another crack at it.
Home

**Bison**          DAY 416
Tried to combine the enthusiasm and en-
ergy of a puppy with the bulk of a bison.
Home

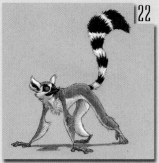

**Ring-tailed Lemur**          DAY 417
Home

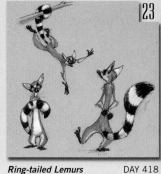

**Ring-tailed Lemurs**          DAY 418
Northridge Mall Food Court

**Snake**          DAY 422
Home

**African Wild Dog**          DAY 423
Memorial Day
Home

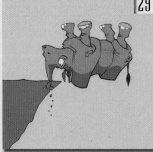

**Rhino**          DAY 424
Home

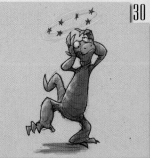

**Dazed Lizard**          DAY 425
Home

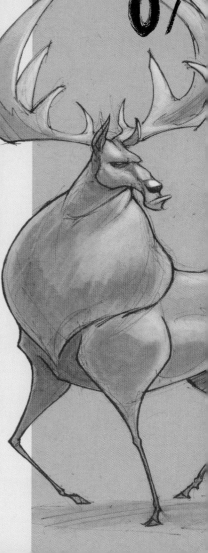

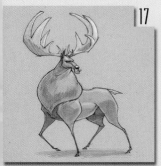

**17**

**Stag** DAY 412
Drawn at the fountain outside of the
Northridge Mall, Northridge, CA

**18**

**Opossums** DAY 413
Northridge Mall Food Court

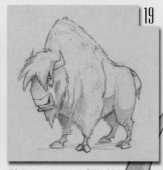

**19**

**Bison** DAY 414
Home

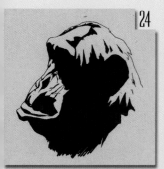

**24**

**Chimpanzee** DAY 419
Home

**25**

**Inverted Pentapus...with Teeth** DAY 420
Toluca Lake Library

**26**

**Slug** DAY 421
I bought Thasja's engagement ring today
in downtown L.A.
Home

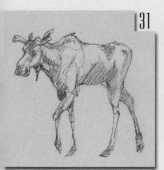

**31**

**Moose** DAY 426
Drawn from a freeze frame of the opening
credits of the TV show *Northern Exposure*.
Home

**1**

**'Noir'-ish Elephant** DAY 427
Home

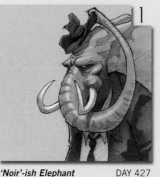

**2**

**Rhino** DAY 428
Home

**3**

**Randy Tijuana & His Beard,** DAY 429
**Monster Pig**
Friend Garth's birthday request.
The Old Spaghetti Factory, Hollywood

**4**

**Furry Beasts** DAY 430
Inspired by a photo of a Madagascar
radiated tortoise hatchling.
Home

**5**

**Goat** DAY 431
Home

**6**

**Wilford the Walrus** DAY 432
Inspired by Wilford Brimley's character
in the movie *Cocoon*.
Home

**10**

**Devilish Bull** DAY 436
Home

**11**

**Rabbit** DAY 437
Home

**12**

**Owl Studies** DAY 438
Inspired by the character of Jafar from
*Aladdin*, but with an avian twist.
Home

**13**

**Bald Eagle** DAY 439
Eagles were on my mind because I was
also freelancing on an eagle logo.
Bowyer Oncology Clinic, UCLA

**17**

**Puglet** DAY 443
A cross between a pug and a pig.
Home

**18**

**Harpy Eagle** DAY 444
Home

**19**

**Cuban Hock** DAY 445
Home

**20**

**Tropical Tapir** DAY 446
Home

**7**

**8**

**9**

***Wilford the Walrus No. 2***     DAY 433
I took the previous day's idea and pushed it a little further.
Home

***Dragon***     DAY 434
Inspired by a stained glass window while attending a friend's wedding.
Holy Martyrs Armenian Apostolic Church

***Serval***     DAY 435
Home

**14**

**15**

**16**

***Rat Bobbie***     DAY 440
Home

***Crocodile Thug***     DAY 441
Home

***Scorpion Creature***     DAY 442
Inspired by an image of the top view of a scorpion.
Home

**21**

**22**

**23**

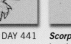

***Yellow Lab/Tusked***     DAY 447
***Gundarian Retriever Mix***
Los Angeles International Airport, Gate 54B and Delta Flight 816 to Anchorage

***Golden Langur***     DAY 448
Days Inn, Anchorage, Alaska

***Bald Eagle***     DAY 449
Thasja and friend Charity soar to the finish of the Mayor's Marathon, their first.
Days Inn, Anchorage, Alaska

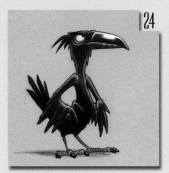

**24**

***Raven***      DAY 450
Inspired by the many ravens in the artwork
at the Alaska Native Heritage Center.
Days Inn, Anchorage, Alaska

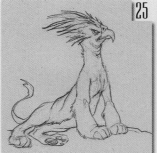

**25**

***Wingless Griffin***      DAY 451
Parking lot of the General Store
in Glitter Gulch, outside of Denali
National Park, Alaska

**26**

***Dall Sheep***      DAY 452
This was as close as we got to Dall Sheep
touring Denali. Proposed to Thasja today.
Park's Edge Cabins, Healy, Alaska

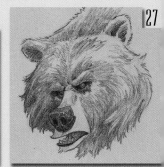

**27**

***Grizzly***      DAY 453
Teddy's Inn the Woods, a B&B six
miles south of Moose Pass, Alaska

**1**

***Sea Lion***      DAY 457
Drawn somewhere over the West Coast
on the flight from Anchorage to Los
Angeles.

**2**

***Cape Buffalo***      DAY 458
Based on a photo by Andy Rouse.
Home

**3**

***Hunchbacked Bear***      DAY 459
Home

**4**

***Shoebill***      DAY 460
Home

**8**

***Penguin***      DAY 464
Home

**9**

***Parrot Thugs***      DAY 465
Home

**10**

***Tiger***      DAY 466
"Content Kitty"
Home

**11**

***Manta with Hi-Beams***      DAY 467
Home

jun
jul
07

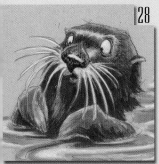

### 28

**Sea Otter** DAY 454
We saw several today while on a boat tour of Kenai Fjords National Park.
The Taroka Inn, Seward, Alaska

### 29

**Puffins** DAY 455
The Taroka Inn, Seward, Alaska

### 30

**Moose** DAY 456
Last night of a fantastic Alaskan odyssey.
Days Inn, Anchorage, Alaska

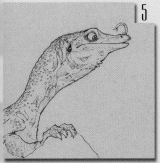

### 5

**Quince Monitor Lizard** DAY 461
Home

### 6

**Black-footed Ferret** DAY 462
Duncan was almost home from collecting dartflower berries when he heard an odd noise behind him… Home

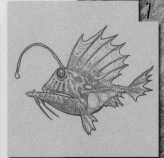

### 7

**Anglerfish** DAY 463
As requested by my friend Davis.
Home

### 12

**Gorilla** DAY 468
Home

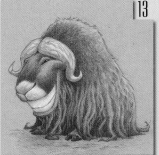

### 13

**Musk Ox** DAY 469
"Warm and Woolly"
Home

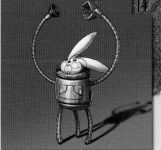

### 14

**Bunny Drone PX42-B** DAY 470
Home

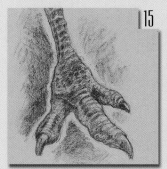

**15**

***Cassowary***     DAY 471
A foot study based on a photo I took at the LA Zoo.
Home

**16**

***Ducks***     DAY 472
Home

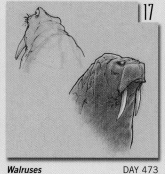

**17**

***Walruses***     DAY 473
Home

**18**

***Monster Bear***     DAY 474
UCLA Bowyer Oncology Clinic & Home

**22**

***Rat***     DAY 478
Home

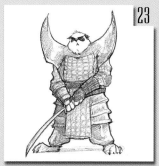

**23**

***Panda***     DAY 479
Home

**24**

***Sumatran Tiger***     DAY 480
"Lasso technique"—using only the lasso tool in Photoshop.
Home

**25**

***Nocturnal Elephant***     DAY 481
Based on a photo taken at the San Diego Zoo during their extended summer hours.
Home

**29**

***Wombat***     DAY 485
I think this one is destined to become a bib or kid's tee: "Wittle Wombat Wuver."
Home

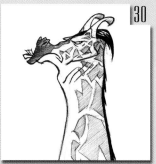

**30**

***Brutish Giraffe No. 1***     DAY 486
I wanted to see if it was possible to make a giraffe with a tough-guy neck.
Home

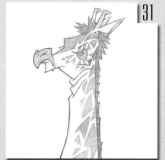

**31**

***Brutish Giraffe No. 2***     DAY 487
Still playing around, though this time I pursued more geometric shapes.
Home

**1**

***Birds***     DAY 488
"*Not* of a Feather"
Home

## jul- aug 07

**19**

**Orca Behemoth**     DAY 475
Scribble Exercise—the scribble it is based on is visible in the top corner.
Home

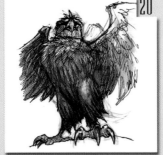

**20**

**Eagle**     DAY 476
Home

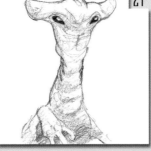

**21**

**T-alien**     DAY 477
Home

**26**

**Marine Iguana**     DAY 482
"Irv"
Home

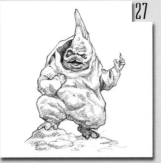

**27**

**Garblin**     DAY 483
Inspired by a black garbage bag under the dining room table full of rollerhockey stuff.
Home

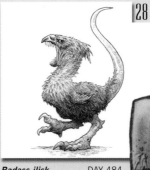

**28**

**Badass-ilisk**     DAY 484
The basilisk is a mythical reptile which can cause death just with its breath.     Home

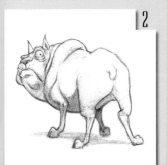

**2**

**Bulldog**     DAY 489
Home

**3**

**Bull(y) Frog**     DAY 490
Home

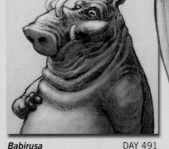

**4**

**Babirusa**     DAY 491
A study for Bamboo Bob, a character for a children's book I'm working on.
Home

**5**

***Alien Mule***      DAY 492
Home

**6**

***Saggy Bunnies***      DAY 493
Home

**7**

***Saber-toothed Cat***      DAY 494
Requested by my friend Brian when we
had lunch the previous weekend.
Home

**8**

***Arachnid-Fish Guy***      DAY 495
I just let the pencil be guided by the
subconscious on this one.
Home

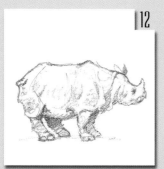

**12**

***Rhino***      DAY 499
Home

**13**

***Armadillo***      DAY 500
Home

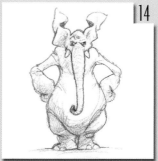

**14**

***Elephant***      DAY 501
Home

**15**

***Aye-aye***      DAY 502
Home

**19**

***Cassowary***      DAY 506
Home

**20**

***Baron von Woof***      DAY 507
Home

**21**

***The Queen***      DAY 508
"Her Majesty"
Home

**22**

***Rat***      DAY 509
Home

**Hermit Crab**                    DAY 496
My sister's b-day request: "A hermit crab
with an architecturally-elaborate shell."
Home

**Scribblemaus**                    DAY 497
Scribble Exercise
Home

**Babirusa**                    DAY 498
Is he running *to* something or *from*
something?
Home

**Arachnerds**                    DAY 503
Home

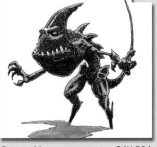

**Demonoid**                    DAY 504
Home

**Insectoid Thumbnails**                    DAY 505
Home

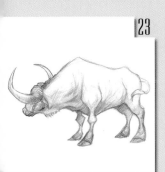

**African Buffalo**                    DAY 510
Home

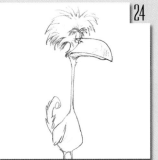

**Goofy Lookin' Bird**                    DAY 511
Home

**Bear**                    DAY 512
Home

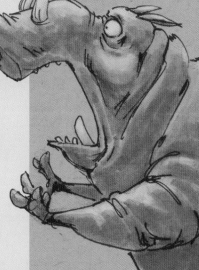

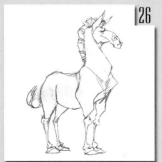

**Horse**     DAY 513
Claire Wendling's drawing style was in my head when I did this one.
Home

**Lion Cub**     DAY 514
First I drew a realistic study followed by a more cartoony one.
Home

**The Kothagi**     DAY 515
A race of celestial ape gods who are made of stars and solar systems.
Home

**Sticky-Note Gnu**     DAY 516
Drawn on a Post-It note at my publisher' studio (shown actual size).
Design Studio Press, Culver City, CA

**Stilted Tortoise**     DAY 520
Drawn on the patio while playing *Scrabble* with friends.
Home

**Beaver**     DAY 521
"Rodent Rapper?"
Home

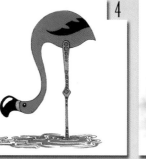

**Flamingo**     DAY 522
Home

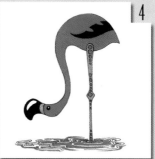

**Elephant**     DAY 523
"Smitty the Smoggy"
Rocket Smog, Inc., Culver City, CA

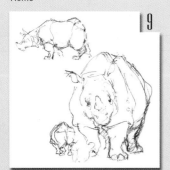

**Indian Rhino**     DAY 527
"Graham"
Drawn from life.
San Diego Zoo

**Armadillo Troll**     DAY 528
Home

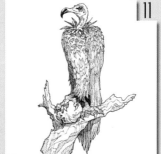

**Hooded Vulture**     DAY 529
Home

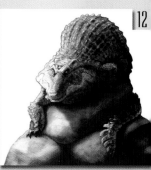

**Crocodile**     DAY 530
Home

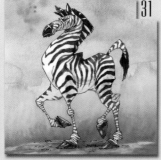

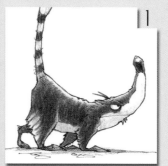

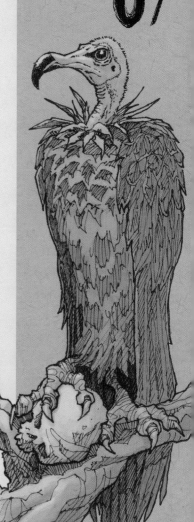

**30**

**31**

**1**

*Gnu*       DAY 517
"Gnu Part Deux"
Home

*Zebra*       DAY 518
Requested by my friend Adrienne on her
golden birthday.
Home

*Coati*       DAY 519
Home

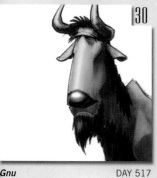

**6**

**7**

**8**

*Owls*       DAY 524
Home

*Madame Zerwilliger*       DAY 525
This raccoon's name is a play on former
Twins 1st base coach Wayne Terwilliger.
Home

*Panther*       DAY 526
Drawn by flashlight in a tent while
sleeping over at the San Diego Zoo.

**13**

**14**

**15**

*Hooded Menace*       DAY 531
Home

*Armadillo*       DAY 532
It looks like he has a pretty comfortable
built-in rocking chair.
Home

*Roly Poly Demon*       DAY 533
Home

**Colobus Monkey**          DAY 534
Home

**Zombie Frog**          DAY 535
Home

**Maned Skelm**          DAY 536
Home

**Red Space Baboons**          DAY 537
Home

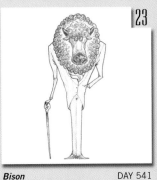

**Bison**          DAY 541
"Shaggy Sophistication"
Home

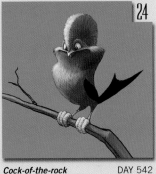

**Cock-of-the-rock**          DAY 542
"Xavier Zankou"
Home

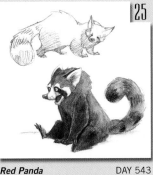

**Red Panda**          DAY 543
Home

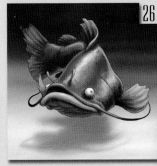

**Catfish**          DAY 544
"Gary the Omniscient Catfish"
Home

**Unfinished Serpent**          DAY 548
Home

**Troll**          DAY 549
Home

**Tyrannosaurus Rex**          DAY 550
For this one, I wanted to practice rim
lighting a character.
Home

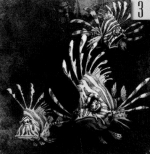

**Lionfish**          DAY 551
Home

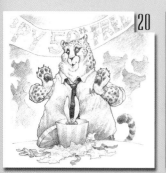

**20**

**Cheetah**                    DAY 538
"Fred Turns Fifty"
Home

**21**

**African Wild Dog**          DAY 539
An effort to improve my digital painting
skills; based on a photo by Calvin Jones.
Home

**22**

**Ape**                       DAY 540
In my car, parked on Ventura Blvd.,
while waiting to have dinner with
friends.

**27**

**Mandrill**                  DAY 545
Home

**28**

**Mandrill (Flip Side)**      DAY 546
At the zoo, my wife remarked that they
have "the most phenomenal butts in
the animal kingdom."          Home

**29**

**Powder Blue Pig**           DAY 547
Home

**4**

**Warthog**                   DAY 552
I imagined this "warthog on 'roids" as I was
drifting off to sleep the previous night.
Home

**5**

**Capuchin Conductor**        DAY 553
Home

**6**

**Naked Mole Rat**            DAY 554
Drawn while watching an old Abbott &
Costello film.
Home

| S | M | T | W |
|---|---|---|---|

**7**

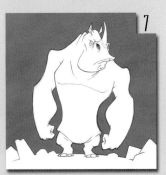

**Rhino** DAY 555
Home

**8**

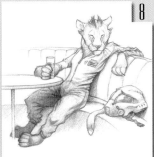

**Lioness** DAY 556
Colonel Astrellis of the Royal Atmospheric Defense Force.
Home

**9**

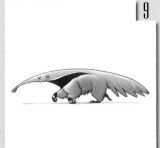

**Anteater** DAY 557
"Anteater Arc"
Home

**10**

**Moth** DAY 558
"Talk to the Hand"
Home

**14**

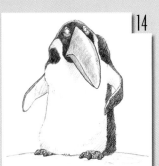

**Penguin** DAY 562
I replaced his normally slender bill with that of a toucan.
Home

**15**

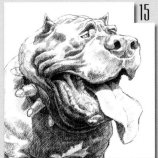

**Italian Bull Mastiff** DAY 563
Home

**16**

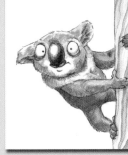

**Koala** DAY 564
Based on a photo taken at the San Diego Zoo.
Home

**17**

**Pudlin** DAY 565
Home

**21**

**Goldfish** DAY 569
"Dearly Departed"
Hubert H. Humphrey Terminal, Gate H5
Minneapolis

**22**

**Zebra** DAY 570
"Major Stripes"
Home

**23**

**Rabbit and Snake** DAY 571
"Turning of the Tide"
Sherman Oaks Galleria parking ramp (killing time waiting for a client) and Home

**24**

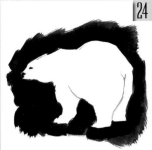

**Polar Bear** DAY 572
Quickly painted the background color while defining the bear's basic shape.
Home

142

oct 07

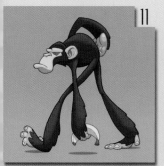

**Chimpanzee**  DAY 559
"It's My Butt...I'll Scratch It If I Want To"
Done at home after a day spent drawing
stylistic monkeys for a freelance project.

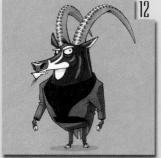

**Sable Antelope**  DAY 560
"Mayor Neighs"
Home

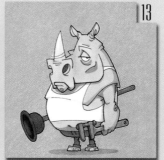

**Rhino**  DAY 561
Home

**Sperm Whale**  DAY 566
Drawn while heading out of town for
my 10-year college reunion.
Los Angeles International Airport, Gate 35

**Turtle**  DAY 567
"Mr. Stu Studly—God's Gift to Reptiles
of the Female Persuasion?"
Russ & Charity's, De Pere, WI

**Sloth**  DAY 568
A combined request of friends Jodi &
Michael.
Russ & Charity's, De Pere, WI

**Peacock-Turkey**  DAY 573
If turkeys were as beautiful as peacocks,
would they still be our Thanksgiving
meal-of-choice?  Home

**Ox**  DAY 574
"Death and Axes"
Home

**Alien**  DAY 575
I didn't realize this until after, but his spe-
cies must be native to the planet Phallux.
Home

**Bald Eagle** DAY 576
Inspired by an unused sketch from another project.
Home

**Bucking Bronco** DAY 577
Drawn while watching the Packers beat the Broncos 19-13 in OT.
Claimjumper's restaurant, Chatsworth

**Late Night Vulcan Gourd** DAY 578
Drawn after an all-nighter designing aliens for *Star Trek*.
Home

**Sidewalk Stain-lien** DAY 579
Inspired by a sidewalk stain I spotted while walking amongst trick-or-treaters.
Inglewood Blvd. and Home

**Dune Cat** DAY 583
Experimented with a new type of water soluble crayon-pencil.
Home

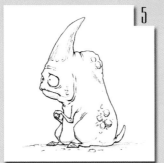

**Horned Rock Nymph** DAY 584
This was done very late at night without too much thought, but I like him.
Home

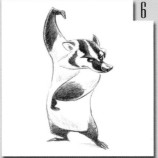

**Badger** DAY 585
"Badger Flamenco?"
Home

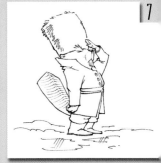

**Beaver** DAY 586
Isn't it a little morbid that he's wearing a furskin hat?
Home

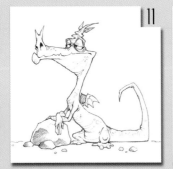

**Dragon** DAY 590
Home

**Mr. Hodgepodge** DAY 591
I have no idea where this one came from; an (over)active imagination I guess.
Home

**Elephant** DAY 592
"Pachyderm Plummet"
Home

**Capybara** DAY 593
Home

oct-
nov
07

**1**

**2**

**3**

*Afghan*           DAY 580
Home

*Thick Duck*         DAY 581
Scribble Exercise
Home

*Ssssam Sssspade*     DAY 582
Home

**8**

**9**

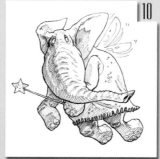

**10**

*Werewolf*           DAY 587
Home

*Eurasian Kingfisher*    DAY 588
"Gone Fishin'"
Home

*Elephant*           DAY 589
"Light on Her Feet"
Is there such thing as a Tusk Fairy?
Home

**15**

**16**

**17**

*Saber-toothed Cat*     DAY 594
"Just Another Day at the Office"
Home

*Rhino*           DAY 595
Rhythm & Hues lunch break

*Penguin*           DAY 596
"Think Big"
Home

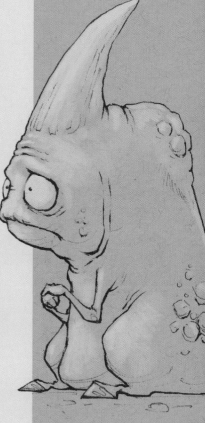

**18**

**Koala Berserker**    DAY 597
Home

**19**

**Meandering Pencil Alien**    DAY 598
I just let the pencil go on this one until some interesting shapes started to appear.
Home

**20**

**Ostrich (& Turkey)**    DAY 599
Chef Ramón says, "Whoah Nelly! Forget the Thanksgiving *turkey* this year!"
Home

**21**

**Extreme Perspective Panther**   DAY 600
Started at the UCLA Bowyer Oncology Clinic and finished at Los Angeles International Airport, Gate 56.

**25**

**Fish**    DAY 604
"Fins of Fury!"
Home

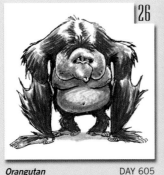

**26**

**Orangutan**    DAY 605
Rhythm & Hues lunch break

**27**

**Porcupine**    DAY 606
"Slab of Porcupine"
Rhythm & Hues lunch break and Home

**28**

**Big Ass Horned Rock Nymph**   DAY 607
Perhaps this is Day 584's older brother
Home

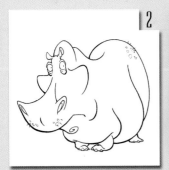

**2**

**Hippo**    DAY 611
Home

**3**

**Chimpanzee**    DAY 612
Digital painting based on a photo taken at the LA Zoo.
Home

**4**

**Tortoise**    DAY 613
Home

**5**

**Bat-eared Furry Tripod**    DAY 61
Rhythm & Hues lunch break

**22**

***Rooster*** DAY 601
Requested by Dierk & Katy since they
were discussing getting some chickens.
Dierk & Katy's, Carolina, Rhode Island

**23**

***Rooster*** DAY 602
Wanted to try another rooster, simplify-
ing some of the shapes this time.
Dierk & Katy's, Carolina, Rhode Island

**24**

***Frog*** DAY 603
Inspired by a billboard.
Duvan & Ming-Yen's, Providence, RI

**29**

***Tamandua Emperor*** DAY 608
Rhythm & Hues lunch break

**30**

***Bear*** DAY 609
This was my state of mind and body
today.
Home

**1**

***Bulldog*** DAY 610
"General Bark"
Grab bag: "Bulldog" & "Walkie Talkie"
Home

**6**

***Expressive Froggy Blob Creature*** DAY 615
The woman I was using for facial expres-
sion reference looked a wee-bit frog-like.
Home

**7**

***Leader of the Flock?*** DAY 616
Now *those* are some mutton chops!
Scribble Exercise
Rhythm & Hues lunch break

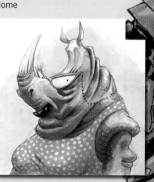

***Rhino*** DAY 617
"Tallulah"
Home

| S | M | T | W |
|---|---|---|---|

**9**

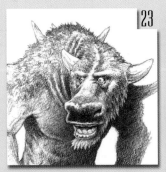

***Pirate Shrimp***      DAY 618
Requested by friend Sean as we took him to a pirate-themed birthday dinner. Garth & Brock's, Manhattan Beach

**10**

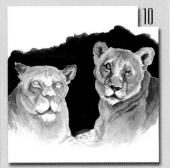

***Lionesses***      DAY 619
A gouache study based on a photo taken at the San Diego Zoo.
Home

**11**

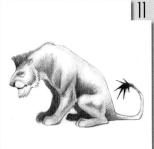

***Big Cat***      DAY 620
Drawn at a strip mall parking lot in Marina del Rey while waiting for some friends to run an errand on our lunchbreak.

**12**

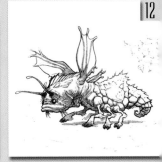

***Seadonkey***      DAY 621
If I were an explorer and discovered a creature I felt compelled to call a "seadonkey," what would it look like?   Home

**16**

***Bikini Babelien***      DAY 625
Home

**17**

***Hook-nosed Bulkasaurus***      DAY 626
Home

**18**

***Lizard***      DAY 627
Drawn while listening to U2's "Out of Control" (Live at Slane Castle version). Home

**19**

***Bat***      DAY 628
"Pssst...Hey Buddy..."
Los Angeles International Airport, Gate 35, heading home for the holidays.

**23**

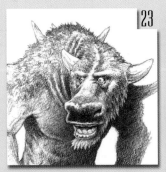

***Minotaur***      DAY 632
Inspired by a book on Greek mythology as I was cleaning my childhood closet.
Mom & Dad's home, Minneapolis

**24**

***Carnivorous Tannenbaum***      DAY 633
"Spot Remover"
Christmas Eve
Grandma C's house, Green Bay, WI

**25**

***Praying Mantis***      DAY 634
Christmas Day, requested by Uncle Mark at breakfast. Drawn throughout the day at Aunt Nancy's & Grandma C's in Wisconsin.

**26**

***Cheetah***      DAY 635
"Streak le Duc"
ShopKo parking lot and Grandma C's house, Green Bay, WI

dec
07

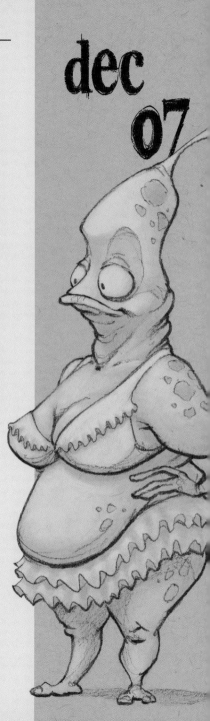

**Seadonkey No. 2**          DAY 622
Attempted another pass, trying for a
less literal approach.
Rhythm & Hues lunch break

**Gorilla Sheik**          DAY 623
Drawn while watching Disney's *Tarzan*.
Home

**Rhinoceros Beetle**          DAY 624
Scribble Exercise, which accounted
for the HUGE horn.
Home

**Elephant**          DAY 629
'Sticky Predicament"
The Chatterbox Cafe, Minneapolis

**Ground Hornbill**          DAY 630
Drawn during intermission at a St.
Paul Chamber Orchestra performance
in St. Paul, MN, and colored at home.

**Fauna Quilt**          DAY 631
The result of asking eight dinner guests
to request an animal.
Mom & Dad's home, Minneapolis

**Takins**          DAY 636
Drawn in my childhood room while look-
ing at a takin painting I did in college.
Mom & Dad's home, Minneapolis

**Cinghiale (Boar)**          DAY 637
Drawn in my sister's old room, inspired by
a stuffed toy I brought her from Firenze.
Mom & Dad's home, Minneapolis

**Serpentine Warrior**          DAY 638
Hubert H. Humphrey Terminal, Gate H2
Minneapolis

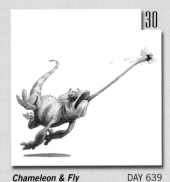

**Chameleon & Fly**　　DAY 639
"Turning of the Tide, No. 2"
Home

**Sloth & Snail**　　DAY 640
New Year's Eve
Home

**Mole Sorceror & Big Nasty**　　DAY 641
"The Silence before the Thunder"
New Year's Day
Home

**Monkey**　　DAY 642
Home

**Ocelot**　　DAY 646
We called one of our college buddies
"Ocelot," but I can't exactly recall why.
Home

**Cow**　　DAY 647
Home

**Porcupine Punk**　　DAY 648
Home

**Mandrill**　　DAY 649
Home

**Skunk**　　DAY 653
Home

**Toucan**　　DAY 654
Spent today drawing "happy, lucky" tou-
cans for a casino logo. This bird's luck,
however, has just run out.　　Home

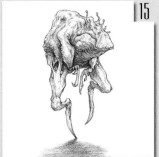

**Spike-toed Biped**　　DAY 655
Home

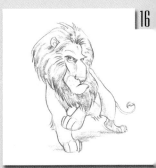

**Lion**　　DAY 656
Home

dec-
jan
08

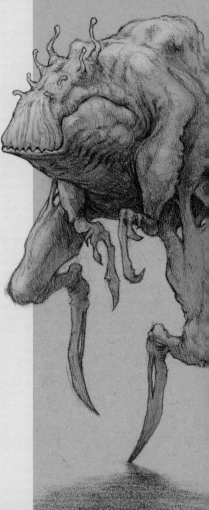

|3|

**Camel**      DAY 643
Home

|4|
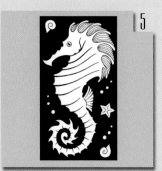

**Gila Monster**      DAY 644
Home

|5|

**Seahorse**      DAY 645
Home

|10|

**Tapir**      DAY 650
Terry Templeton, #22, cleanup hitter and
3rd baseman for the Toluca Thumpers.
Home

|11|

**Ogre**      DAY 651
Requested by Thasja.
Home

|12|

**Snake vs. Beaver**      DAY 652
Done while Thasja beat me at *Scrabble*.
I should've done more thinkin' and
less drawin'.      Home

|17|

**Sir Ratcliffe**      DAY 657
While creating this diminutive-yet-dar-
ing knight, I wondered what his trusty
steed would look like...      Home

|18|

**Sir Ratcliffe's Trusty Steeds**    DAY 658
...a Bulldog Lizard, Rhino-toad Iguana,
Basilisk Centipede, Loping Beetle
Lizard, or Slug Snake?      Home

|19|

**Alien**      DAY 659
"The Hatching"
Drawn after seeing *Cloverfield* tonight.
Home

**Tortoise Mechanic** DAY 660
Gearplate, a crotchety greaseshell who helps keep the Vicillian Armada running (relatively) smoothly. Home

**Giraffe** DAY 661
"A New Perspective"
Home

**Glyptodont** DAY 662
Home

**Squidfish** DAY 663
Home

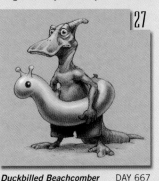

**Duckbilled Beachcomber** DAY 667
Home

**Mr. Slick** DAY 668
A snake with a creepy hairdo? Where do I get this stuff?
Home

**Dung Beetle** DAY 669
Home

**Dung Beetle** DAY 670
Dung beetle Don slowly counts the days until his pension kicks in.
Home

**Frog** DAY 674
"Amphibious Anxiety"
Home

**Hyena** DAY 675
Rhythm & Hues lunch break

**Jackal** DAY 676
Home

**Victoria Crowned Pigeon** DAY 677
"Pigeon Punk"
Home

 24

 25

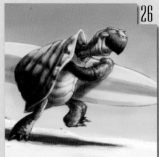 26

**jan- feb 08**

***Elephant***      DAY 664
"A Tardy Sir Douglas on the Morning Commute"
Home

***Gorilla***      DAY 665
Home

***Tortoise with 'Tude***      DAY 666
Home

 31

 1

 2

***Cycloptic Insectoid***      DAY 671
The first DZ original that I have given away; on an envelope sent to friend JJ.
Rhythm & Hues parking lot

***Alien Fido***      DAY 672
"Bulldog" from Zelkon 5 (based on the skull of an actual bulldog).
Home

***Beached Octopus***      DAY 673
Does it make much sense for an aquatic animal to spend a day in the sun and the sand? Oh well.      Home

 7

 8

 9

***Gobblieus Rex, the Turkey King*** DAY 678
Grab bag: "Turkey," "Disgusting," and "Throne"
Home

***Alien Thoroughbred***      DAY 679
Inspired by a trip to my publisher and seeing an in-progress glimpse of *Alien Race*.
Home

***Ostrich***      DAY 680
Home

**Hummingbird** DAY 681
It's important to know when to say,
"When."
Home

**Otters** DAY 682
Home

**Unicorn** DAY 683
Done after a day of drawing unicorns
for a freelance project.
Home

**Unicorns** DAY 684
With unicorns still on the brain
wanted to try some that were "rough
around the edges." Home

**Alien Guard Dog** DAY 688
Very loosely based on a Doberman
pinscher.
Home

**Mouse** DAY 689
Sir Ratcliffe's faithful companion?
Home

**Frog** DAY 690
Home

**Fish** DAY 691
"Sushi Chef"
Home

**Chinchilla** DAY 695
"Chinchilla, Jacked Around"
Requested by my sister.
Home

**Fairy** DAY 696
"Fairy Zap!"
Scribble Exercise
Home

**Panda Moor Goldfish** DAY 697
These strange creatures were discov-
ered while seeking panda reference for
another project. Home

**Aristocratopus** DAY 698
Home

feb~
mar
08

**Frightened Porcupine**     DAY 685
No, this isn't my reaction to Valen-
tine's Day.
Home

**Great Gray Owl**     DAY 686
Home

**Kangaroo**     DAY 687
Home

**Ibex**     DAY 692
Grab bag: "Ibex" and "Statistician"
Home

**Raccoon**     DAY 693
This guy started with big eyes and the nee-
dle nose, eventually becoming a raccoon.
Home

**Bison**     DAY 694
Drawn on the ferry returning from
Catalina Island, where a herd of
imported bison roam.

**Okapi**     DAY 699
A warm-up study while exploring cover
ideas for the first *Daily Zoo* book.
Home

**Dove of Possibility**     DAY 700
Leap Day
Inspired by the music of U2.
Home

**Aardvark**     DAY 701
Home

**2**

**Moose**      DAY 702
Based on a photo from a fantastic face-to-face encounter in Alaska.
Home

**3**

**Wombat Squire**      DAY 703
Requested by Thasja.
Home

**4**

**Scarlet Macaw**      DAY 704
Home

**5**

**Hyena**      DAY 70*
"Sad Clown"
Rhythm & Hues lunch break and Hom

**9**

**Leopard Seal**      DAY 709
Home

**10**

**Space Mercenary**      DAY 710
Home

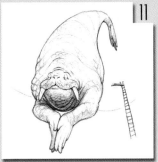

**11**

**Walrus High Dive**      DAY 711
Home

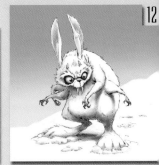

**12**

**Multi-limbed Rabid Mutant Rabbit**      DAY 71
Home

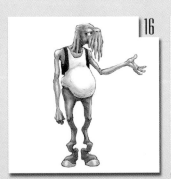

**16**

**Alien Bar Patron**      DAY 716
Inspired by the infamous cantina scene in *Star Wars*.
Home

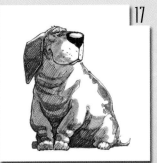

**17**

**Rog the Dog**      DAY 717
Loosely based on one of Thasja's stuffed animals.
Home

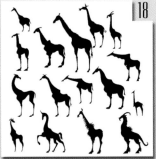

**18**

**Giraffe Thumbnails**      DAY 718
Exploring different possibilities with giraffe silhouettes.
Home

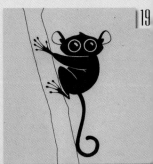

**19**

**Tarsier**      DAY 71
Home

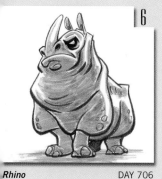

**Rhino** DAY 706
Scribble Exercise
Home

**Droop-billed Snipe** DAY 707
Home

**Armadillo** DAY 708
Thasja requested an armadillo cowboy
on a horse. Not wanting to draw *two*
animals, I cheated a little. Home

**Bull Ram** DAY 713
Drawn digitally with a custom "pencil"
brush designed by artist Paul Lasaine.
Home

**Marcelo the Cat** DAY 714
Marcelo Vignali, fellow artist, saw the
Nuclear Squirrel in Vol. I and said he'd like
to see a whole cast in that style. Home

**Scheming Rat** DAY 715
Home

**Raccoon** DAY 720
Basic shape originated in a digital scribble
pad before being fleshed out in pencil.
Home

**Left-handed Ewe** DAY 721
Tried to discover new shapes and happy
accidents by drawing with my left hand.
Home

**Right-handed Ewe** DAY 722
Back to drawing with my right hand, but
incorporating yesterday's discoveries.
Home

# mar 08

**Elephant**      DAY 723

Drawn on an envelope for Dr. Patch Adams, introducing him to the Daily Zoo.
Home

**Gorilla**      DAY 724

"Be Strong, Be Brave"
Home

**Fox Super Hero**      DAY 725

Home

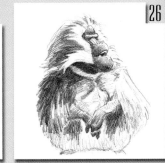

**Gelada Baboon**      DAY 726

Home

**Dragon**      DAY 730

Home

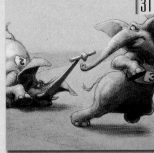

**Elephants**      DAY 731

"Fresh Legs"
Home

# mar 08

**Gelada Baboon**          DAY 727
ame monkey, different artistic style.
lome

**Thirsty Frog with Eyebrows**     DAY 728
Home

**Fishy Muse**          DAY 729
Home